WESTBURY
THROUGH TIME
Elizabeth Argent

AMBERLEY PUBLISHING

Acknowledgements

The majority of the images of old Westbury have come from collections built up over many years by John Harris, Ivan Clark, Tony & Lynda Hannaford and Westbury Heritage Society. I am very grateful to them for giving me such a vast range of material to choose from.

My thanks go also to the following, who provided additional pictures, advice, information or other assistance during the preparation of this book: Derek Whale, Agnes Capes, Bill Clark, Philip Argent, Keith Harvey, staff at the Wiltshire & Swindon History Centre, staff and Tuesday afternoon swimmers at Westbury Pool, *White Horse News*, CO at Leighton House, Westbury Rotary Club.

First published 2013

Amberley Publishing
The Hill, Stroud, Gloucestershire, GL5 4EP
www.amberley-books.com

Copyright © Elizabeth Argent, 2013

The right of Elizabeth Argent to be identified as the Author of this work has been asserted in accordance with the Copyrights, Designs and Patents Act 1988.

ISBN 978 1 4456 1764 0 (print)
ISBN 978 1 4456 1782 4 (ebook)

British Library Cataloguing in Publication Data.
A catalogue record for this book is available from the British Library.

Typesetting by Amberley Publishing.
Printed in Great Britain.

Introduction

Lying below the north-western edge of Salisbury Plain, Westbury is most well known for the White Horse overlooking the town and as a junction on the main line from Paddington to the West. The name of this small Wiltshire town is thought to mean 'the fortified place in the west' and dates from Saxon times. However, evidence of human activity from the Stone Age to the Roman era has been found. A long barrow at Bratton Castle and several round barrows on the downs to the south of the town are thought to predate the Bronze Age, and a midden discovered on Bratton Road suggests later settlement. Just above the White Horse the ramparts and ditches of an early Iron Age site are clearly visible.

The area around Westbury was in the earliest part of Roman Britain. Considerable finds made in the late nineteenth century show a prosperous settlement around The Ham, to the north of the railway station. There was also activity at Wellhead, where a lime kiln has been found, and burials have been discovered at various locations.

Although there is no proof, the oldest White Horse in Wiltshire is said to have been first carved into the chalk to commemorate King Alfred's defeat of the Danes at the Battle of Ethandun (Edington) in 878. It is known that the present shape dates from 1778 and replaces a smaller, cruder figure. It is unique among the other Wiltshire white horses in showing a standing, as opposed to a running, figure.

The first documented reference to Westbury is in Domesday (1086). Prior to the Norman Conquest it was owned by Edith, the wife of Edward the Confessor, but by Domesday ownership had passed to King William. It was a substantial manor with a church, corn mills, beekeepers, potters and swineherds.

At the end of the medieval era, the local cloth industry developed; spinning and weaving continued to ensure the town's prosperity. In 1323 there were two mills in the town and a conveyance for a corn mill

in 1428 may relate to a site on Bitham Brook to the east of Fore Street. At Angel Mill, twelfth- to fourteenth-century watercourse revetments have been found. Bitham Mill in Alfred Street may also be on the site of a medieval mill, as its first recorded mention in a conveyance from 1570 relates to an already established building. In 1433 a Westbury clothier was doing business in Lynn on the East Coast, and in 1448 the town sent its first two members to Parliament. The town's wealth is evident in the parish church of All Saints, which was largely rebuilt at this time.

The Market Place probably dates from the thirteenth century. In 1252 the first charter for a weekly market and annual fair was granted, but none has been held regularly since the middle of the nineteenth century; nowadays it is a venue for occasional visits by French stallholders.

After economic depression during the first half of the nineteenth century, the town's fortunes were revived by the coming of the railway, and Abraham Laverton became the new owner of the two town centre mills, Angel and Bitham. Westbury became famous for its fine quality cloth. Although the mills closed just over a century later, the buildings survive, and have been converted to housing and shops. The legacy of Abraham and his nephew and successor, William, is also found in the Laverton building, the Victorian swimming pool, and Prospect Square, built to house millworkers.

In the second half of the nineteenth century an ironworks prospered, exploiting iron ore deposits that may have originally been used in Roman times. Gloving was another important industry, providing employment for women working at home.

As the traditional industries declined and died out, the natural resources gave rise to a new one. A huge quarry was opened on the hills to the west of the White Horse and a pipeline transported chalk to a cement works on the edge of town. Here, clay was dug and added to make the finished product.

Currently several industrial estates around the town provide employment. The largest, on the site of a Second World War ordnance depot and prisoner of war camp, still has some units housed in former Army storage hangers.

Today's visitor will discover Westbury to be a town aware of and proud to share its heritage. A short walk around provides a fascinating glimpse into its rich and varied past.

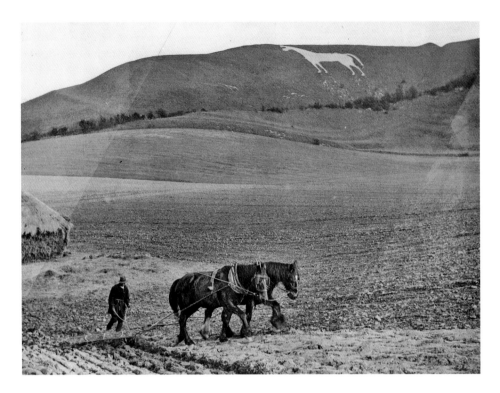

White Horse and Hills, 1932

The White Horse looks out over the town from the escarpment of Salisbury Plain. Below the chalk, a narrow band of greensand is easily cultivated and sheep were traditionally grazed on the hills. An annual sheep fair was held in the first week of September until the 1930s. Today the hills are popular with walkers and hang-gliders. National and local events are celebrated by the lighting of a beacon, most recently in 2012 for the Queen's Diamond Jubilee.

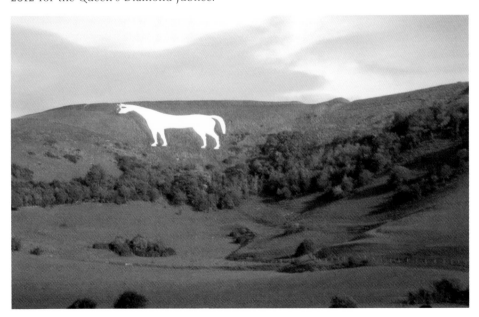

White Horse, Camouflaged in the 1940s and the Repainting in 2012

During the Second World War the Horse was camouflaged so that it would not be a navigational aid to enemy bombers. Being on a very steep slope, rain regularly washed the chalk away, so a stone border and drains were installed in 1873 and the chalk replaced with concrete in 1957. By early 2012 the paint had again turned grey. Volunteers led by the town's Rotary Club carried out the much needed cleaning and repainting. (Photograph below courtesy of *White Horse News*)

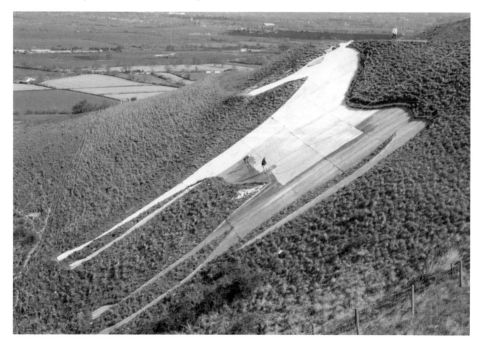

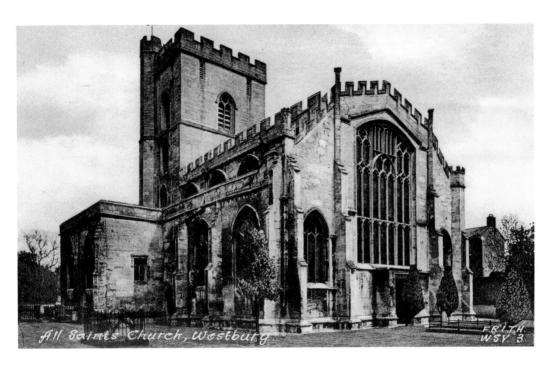

West Front, All Saints Parish Church

Unchanged for centuries, the oldest part of the church dates from the late fourteenth century, although it probably stands on the site of Saxon and Norman churches. Rebuilding in the fifteenth century added the west window, realigned the roof and increased the height of the tower. The enclosed churchyard contains good examples of eighteenth-century altar tombs.

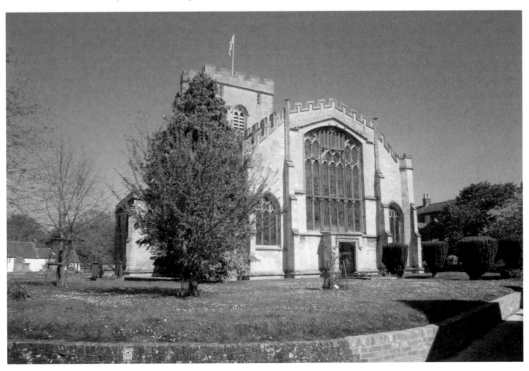

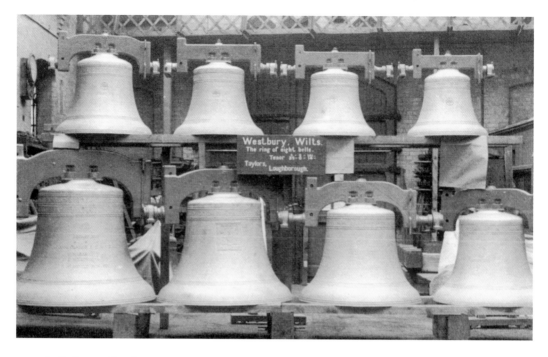

Bells from All Saints, 1921

The oldest of the original peal of six dates from 1616 and has the English coat of arms on one side and the Ley family crest on the other. When they were recast in Loughborough in 1921 the original inscriptions were retained and two bells added. They were rehung on a new steel frame, replacing the original oak. As the second heaviest peal of eight in England, they are popular with visiting bell-ringing teams.

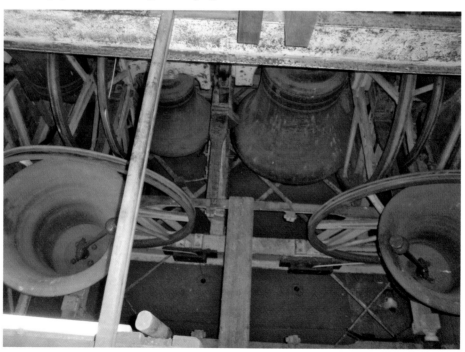

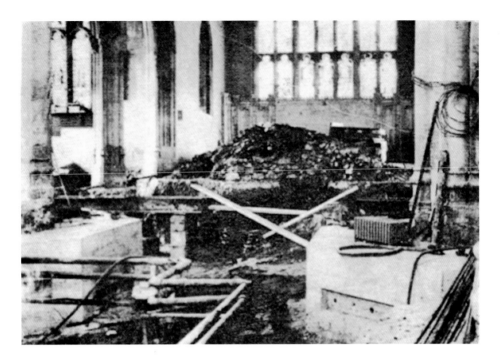

All Saints Interior, 1969

In late 1968, water from a broken culvert was found in the clay foundations, causing cracks to appear in walls and the tower to lean. Residents of nearby houses were offered alternative accommodation and the infant school was moved to temporary premises. To save the building, 137 piles were inserted to a depth of up to 50 feet and attached to concrete collars around the bases of the columns. The church was able to reopen in November 1969.

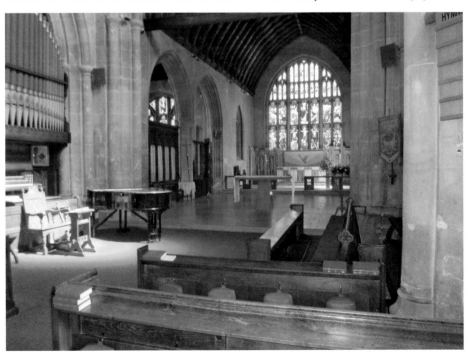

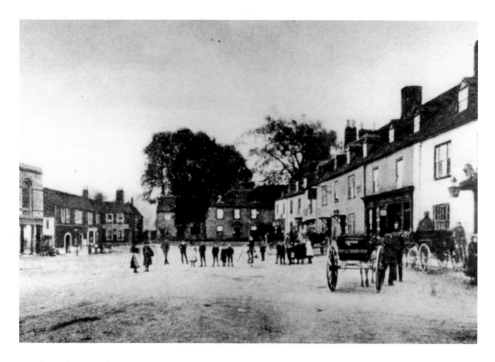

Market Place and Cannon Green, 1890s

The Lopes Arms in the corner on the left is beside the entrance to the churchyard. Cannon Green, at the far end, is an eighteenth-century terrace. On the right are shops and the Crown Hotel, one of four pubs in the Market Place. The porch of the White Lion is just visible. The shop next to it was Chard's chemists for many years. It was then a convenience store and is now a vet's practice.

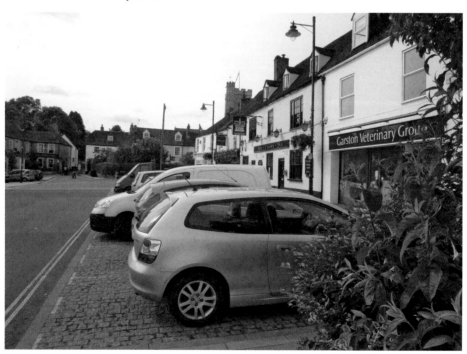

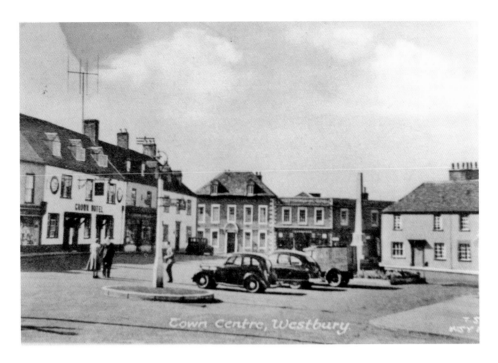

Market Place, *c.* 1950

The town's war memorial was dedicated in July 1921 and removed in 1975 after a new monument was installed in the library gardens. In the centre, eighteenth-century Bank House was once owned by Sir Massey Lopes. From 1923 to 1971 it housed Barclays Bank. The shop on its right is the Westbury branch of the Trowbridge Co-op. To the left of the Crown, Wootten's grocers is now a wine bar. The White Lion has been recently sold for redevelopment.

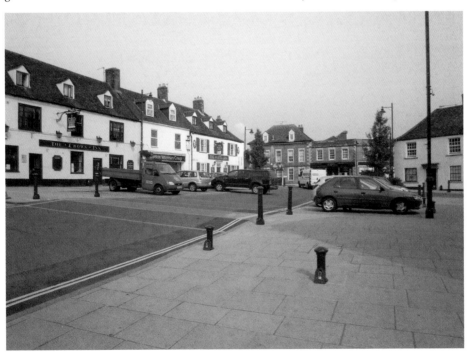

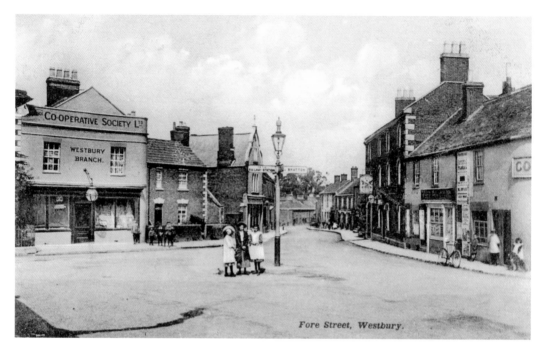

Fore Street, Westbury.

Co-op and Fore Street

On what was once the site of the Guildhall, the Co-op opened in 1909 at the corner of the Market Place and Fore Street; the larger store, selling food, clothes, shoes and furniture, opened in 1937 and closed fifty years later. A variety of businesses have used the premises since. On the right, the Ludlow Arms has lost its top floor in the intervening years.

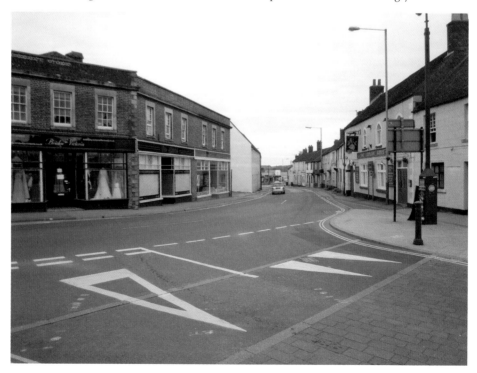

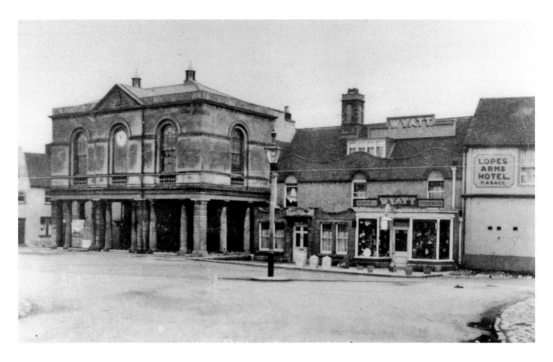

Town Hall, Market Place

A gift to the town in 1815 from Sir Manasseh Massey Lopes, the Town Hall replaced an earlier market hall on this site. The open area provided cover for market traders. County court sittings were held on the first floor until the late 1930s. Later, the town library was housed there and public toilets installed on the ground floor, which was also used as a bus shelter. Sold in 1973, its conversion to shops and offices won an architectural award two years later.

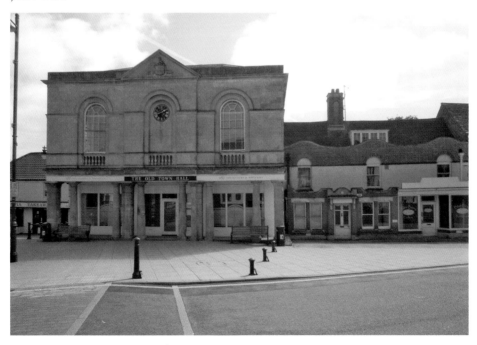

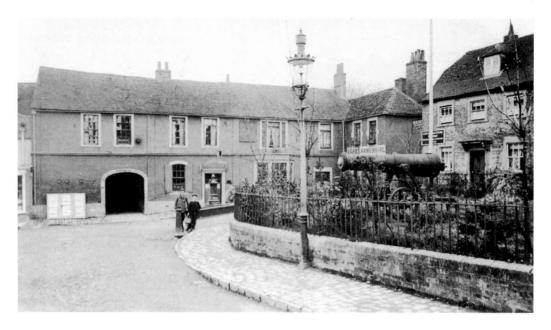

Lopes Arms, Market Place

Thought to have been an inn site since the fourteenth century, its name dates from 1809 when Sir Manasseh Massey Lopes bought the manor of Westbury. From 1754, it had been the Lord Abingdon Arms, after the former landowner. The Russian cannon, a relic of the Crimean War, was removed in 1942 and melted down for the war effort; where it stood is still called Cannon Green.

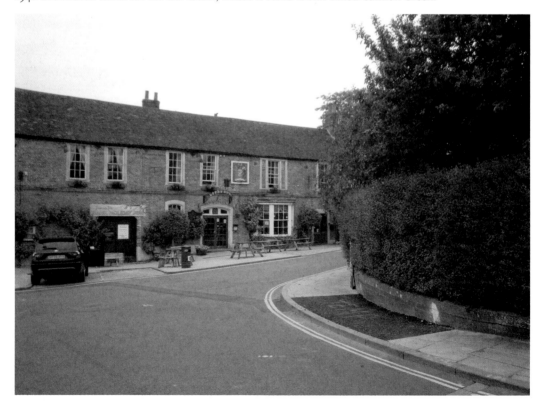

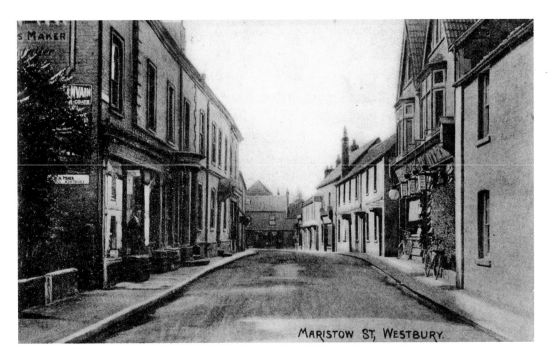

MARISTOW ST, WESTBURY.

Maristow Street from the Market Place, 1920
Formerly Silver Street, it was renamed after the Devon home of the Lopes family. Their local home, the first building on the left where the porch still stands, is from the eighteenth century. Now shops, between the wars Charles Fisher ran a tailoring business at No. 3. Nearly opposite was Frisby's shoe shop, one of very few national chains trading in Westbury.

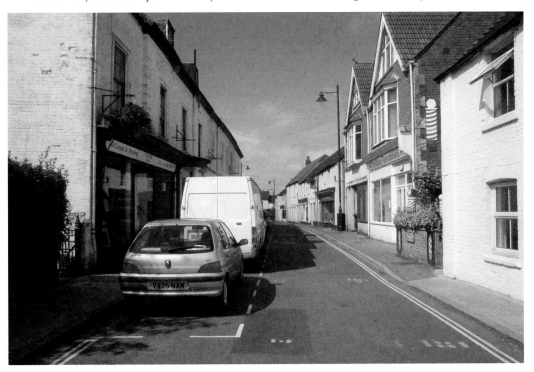

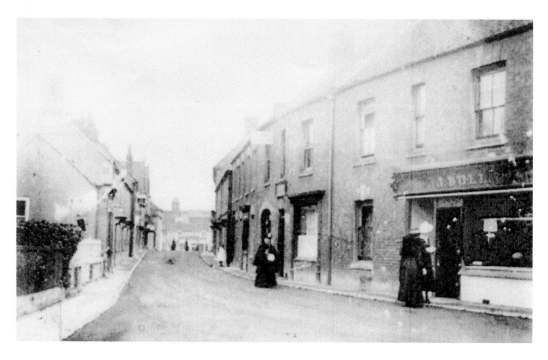

Maristow Street from Edward Street, Early Twentieth Century
Still a mixture of houses and small, locally owned businesses, Maristow Street is one of the oldest parts of the medieval borough. John Bull traded as a butcher for many years, and a family butcher's and a sweet shop can still be found further down the street.

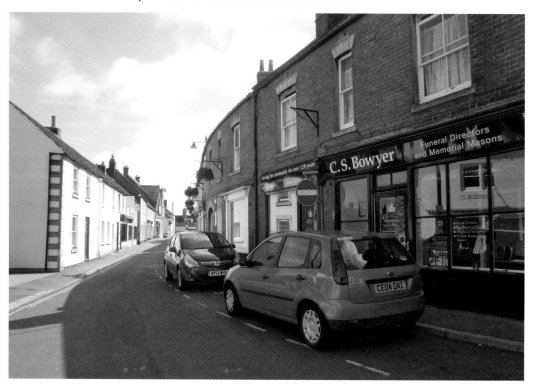

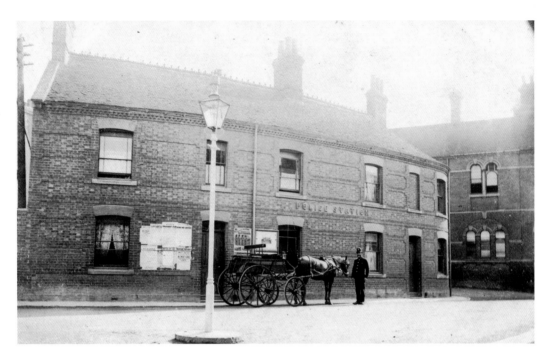

Police Station, Edward Street, 1905

The Wiltshire Constabulary was the first county police force when formed in 1839, so by the time of this picture it had been operating for nearly seventy years. The police station was built before 1875, contained a single cell and was overseen by a sergeant or an inspector. In the 1930s a new station and police houses were built in Station Road, and this building has most recently been used by an accountancy firm.

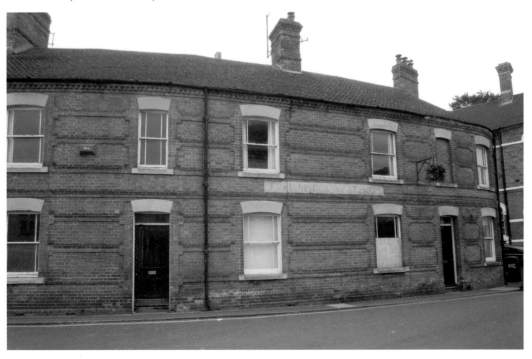

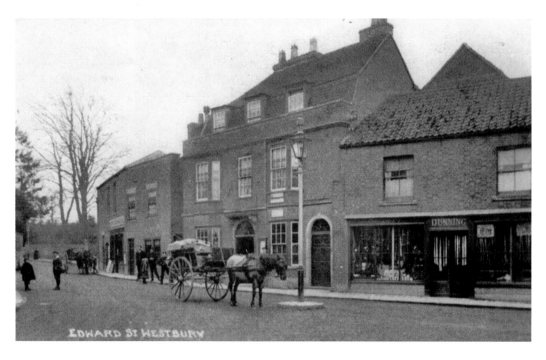

Edward Street Looking Towards Fontainville, Early 1900s
Opposite the police station, Dunning's saddlery was still in business in the 1930s. The large house was the post office from the 1880s, until it was moved further up the street. In the intervening years, the frontage has been altered and the building whitewashed. The Mad Hatter's tea shop is now here; beyond that is Michael's (later Holloway's), stationers and printers. The trees in the background are in the grounds of Fontainville, now the site of the High Street.

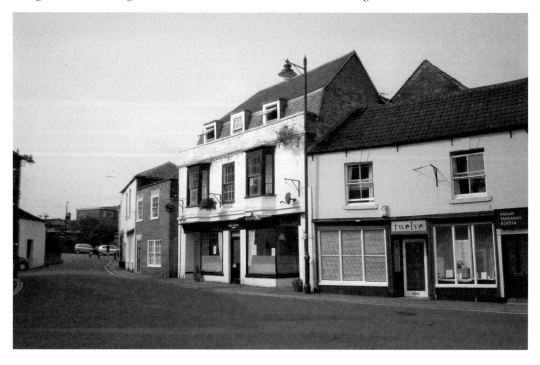

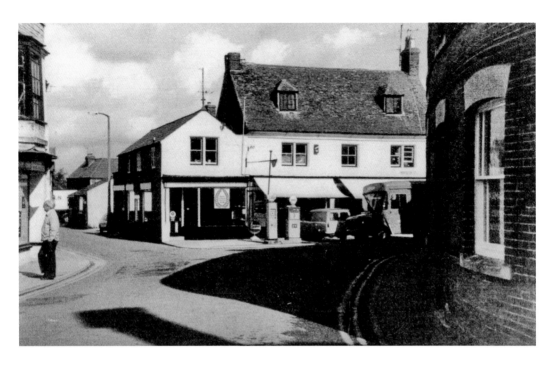

A. Kendrick & Co., Edward Street

Kendrick's, founded in 1920, was for many years a well-known business trading on the corner of Edward Street and Maristow Street as both a motor dealer and an electrical retailer. The workshops and car showrooms (left) extended back to West End. The shop on the right sold a complete range of electrical household appliances and also carried out repairs. After the business closed in 1997 the premises became a charity shop for the Wiltshire Air Ambulance.

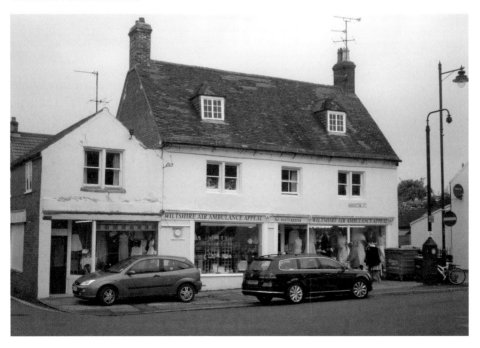

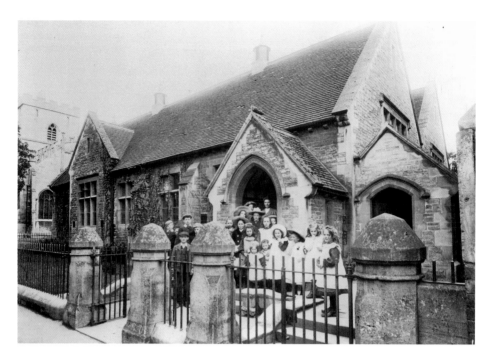

Church of England School, Church Lane

Inscribed above the doorway is 'Church of England Sunday Schools for Girls and Infants 1873'. The building was subsequently the National School for Girls and Infants and, from 1925, the town's mixed junior school. After the new junior school was built in 1959, the top three infants' classes moved in and remained until 1968. It continues in use today as the Parish Rooms. (Photograph above courtesy of the Wiltshire & Swindon History Centre)

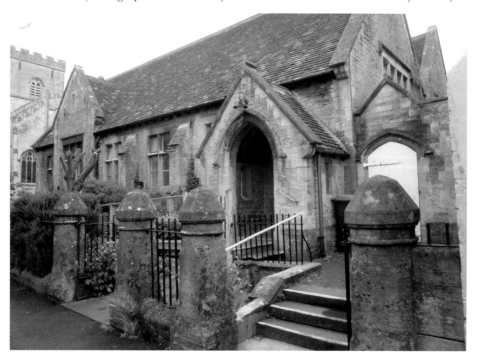

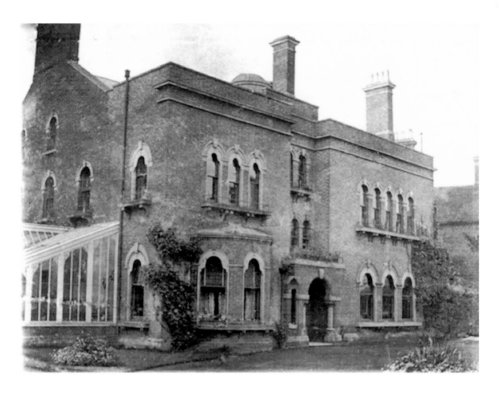

Westbury House, Edward Street (Rear View, c. 1970)

Dating from around 1800, Westbury House was owned by Benjamin Overbury, then William Matravers, joint owners of the adjacent Angel Mill. For a time, Matravers funded a school on the upper floor. Abraham Laverton bought the house shortly after acquiring the mill and lived there until 1880. It has been the town library since 1970, when the conservatory was demolished. The gardens are a public open space.

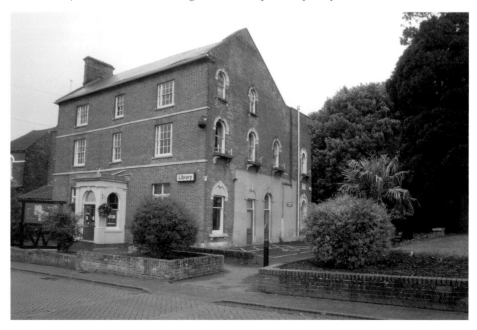

Fontainville, Edward Street

No earlier photograph can be found of this large residence, built around 1816. Its grounds extended from Edward Street almost to Haynes Road. Prominent among its occupants are James Wilson, MP for Westbury and founder of *The Economist*, and the Jefferies family, owners of a gloving company. American soldiers were based there prior to D-Day, after which it fell into disrepair. It was demolished in 1961 to make way for the new High Street.

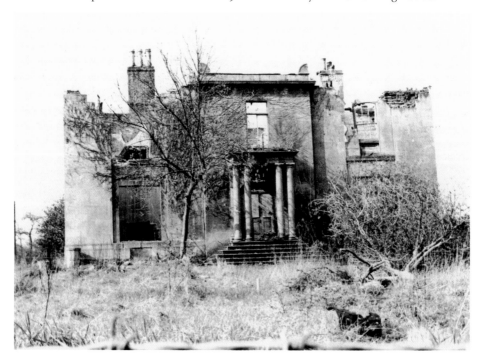

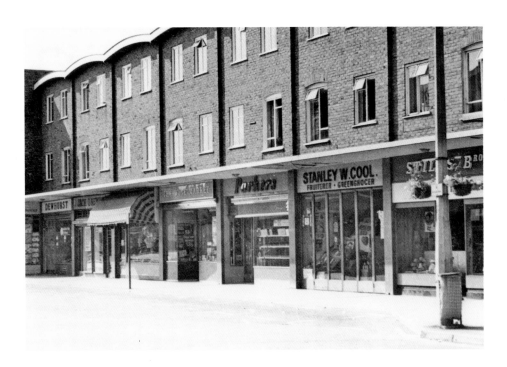

High Street, Late 1960s

Developed from 1962 to 1966, the main part of the High Street consists of thirty shop units with maisonettes above. The first shop opened in January 1963. Of the shops in the photograph, Parkers is still a bakery (the Bath Bakery) and Kevin's Menswear (with the canopy) has doubled in size. There is still a greengrocer, now on the opposite side.

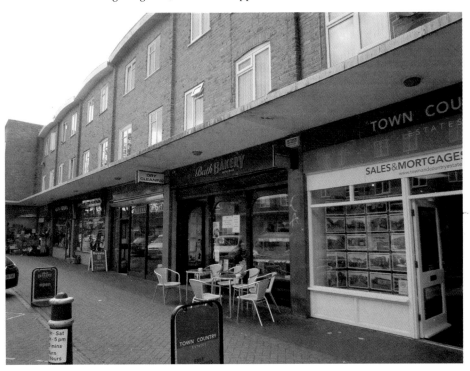

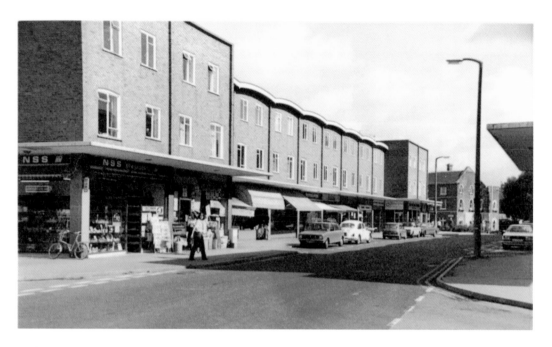

High Street, 1970s

When first built, the High Street was two-way, connecting Haynes Road and Edward Street. In 1992 enhancement work was carried out; traffic restrictions were introduced, and raised flower beds and a seating area were built. The town's summer Street Fair and Christmas in Westbury events see stalls and fairground rides along the street.

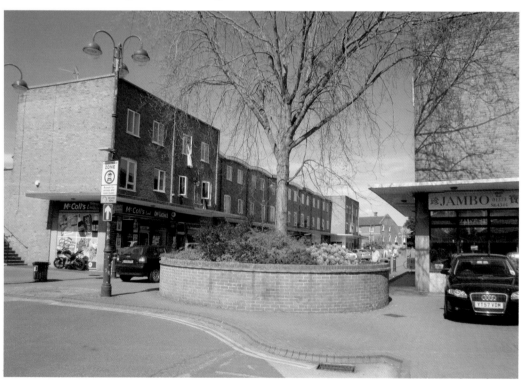

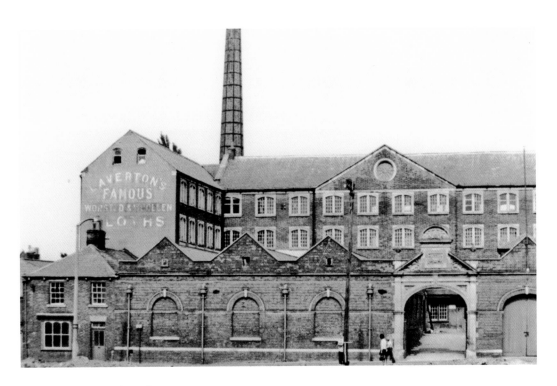

Angel Mill, Edward Street

Probably the first factory in Wiltshire built for steam power, the central building was completed by 1809. Converted to a flour mill in 1845 after its owners' bankruptcy and bought by Abraham Laverton in 1852, it then reverted to producing woollen cloth. The wing on the left was added in 1856 and the surrounding wall in 1868. Production continued under the Laverton name until closure in 1968. After various uses it became housing and shops in the 1990s.

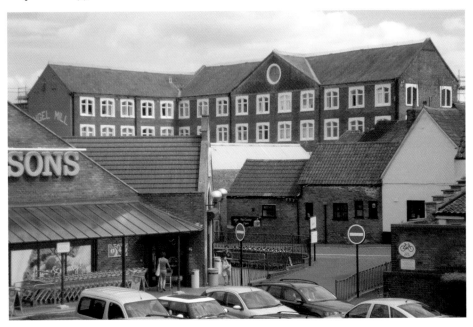

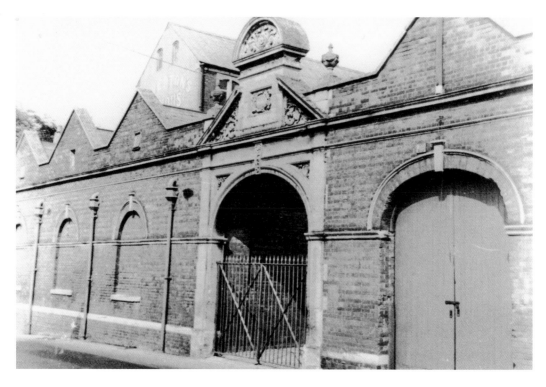

Angel Mill Gates, Edward Street

Behind the wall surrounding the mill in Edward Street and continuing into Church Street was a single-storey extension containing the weaving shed. Despite competition from northern factories and overseas, Laverton's worsted and woollen cloths sold well in foreign and domestic markets, and provided employment in the town. The weaving sheds are now gone, but the outer wall has been incorporated into modern business units.

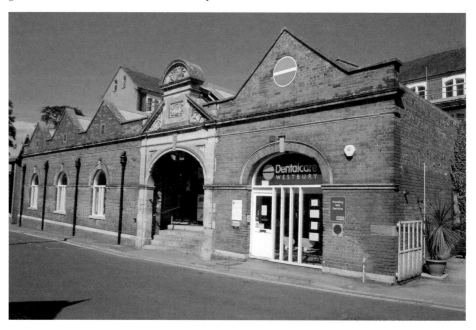

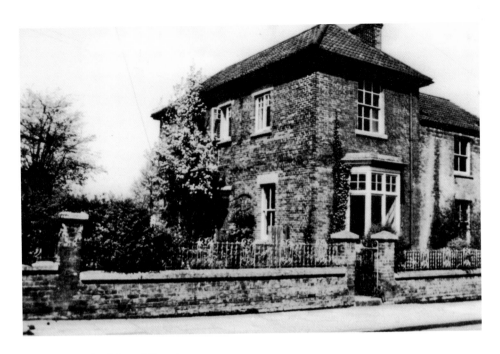

The Vineyards, Edward Street

Miss Preece's 'Establishment for Young Ladies' in the late nineteenth century was later the home of the Taylor family, whose motor engineering business was next door. In 1974 a new Keymarkets store opened on the site. As Coopers supermarket, the enlarged shop was again extended in 1995 with a design mirroring the mill wall opposite. On one section a mosaic honours the town's provision of respite care for children affected by the Chernobyl nuclear accident.

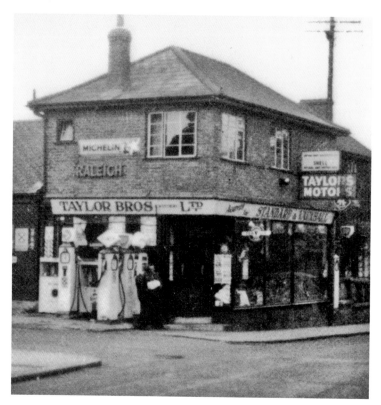

Taylor Bros, Edward Street, *c.* **1950s** Established on the corner of Westbourne Road and Edward Street for over fifty years, the Taylor brothers had the only petrol pump in town in the early 1920s. Their workshops extended along Westbourne Road. Earlier photographs show the shop without its upper storey. It was replaced by a supermarket, owned by Coopers for twenty-three years, and bought by Morrisons in 2009.

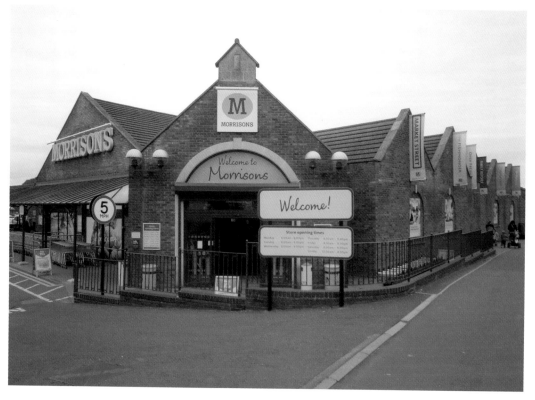

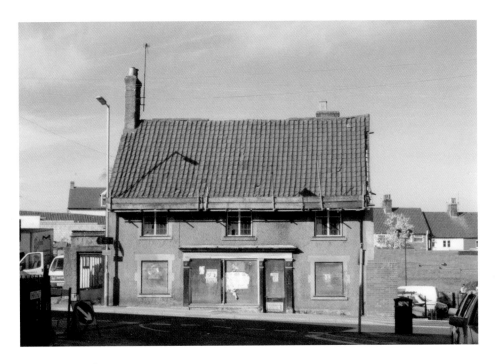

No. 50 Edward Street

The area around the junction of Church Street with Edward Street has been identified as a late medieval suburb. This building and its neighbour, now demolished, show evidence of a sixteenth-century timber frame and were once a factory with house attached. A baker, Raines, had a shop here for part of the twentieth century, the actual bakery being on the left. Unoccupied for many years before renovation in 2000, it is now a lettings agency.

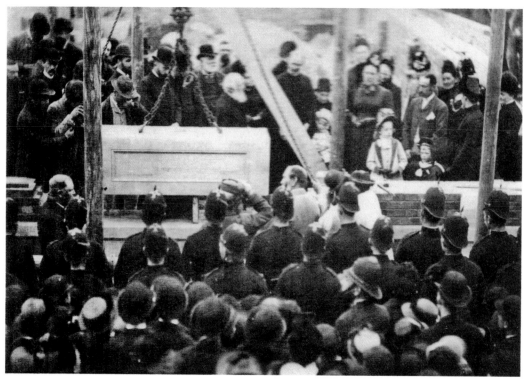

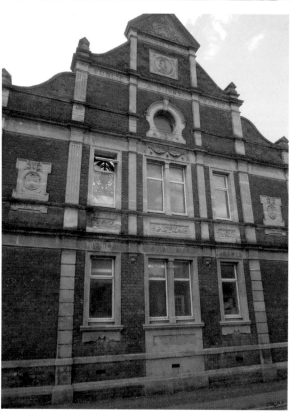

Laying the Foundation Stone for Westbury Swimming Baths, Church Street, 1887

To celebrate Queen Victoria's Golden Jubilee, William Laverton gave the town its swimming baths. The stone was laid on 11 May 1887 and the baths opened just over a year later. The water was drawn from Bitham Springs and changed once a week; on Monday it was cold and clean, but by Saturday it had warmed up, and become rather murky. As well as the pool there were six private baths for men and four for women.

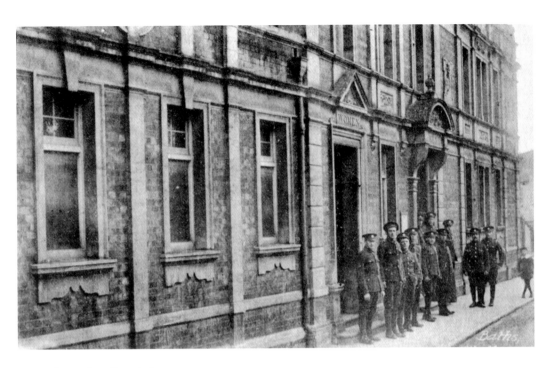

The Baths, Church Street, 1915

For nearly a century the baths were only open for swimming during the summer. In winter a floor was laid over the pool and it became a hall used for dances and indoor sports. During the First World War soldiers were billeted there. Separate entrances were provided for men and women; the men's was more elaborate. In 1984 the baths were upgraded and a new entrance was built towards the rear of the building.

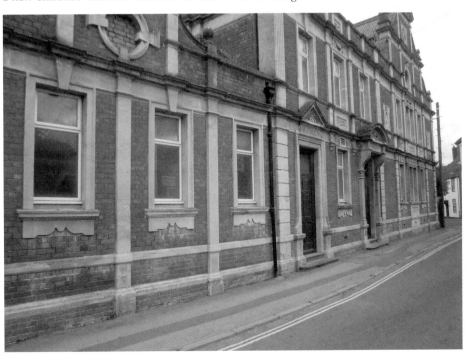

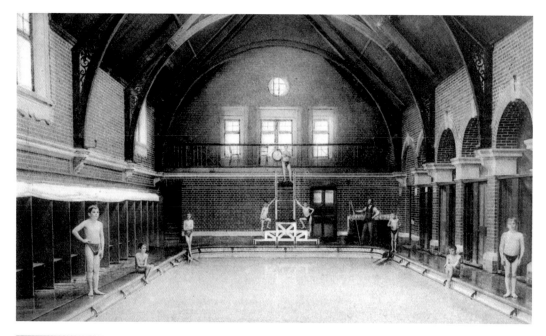

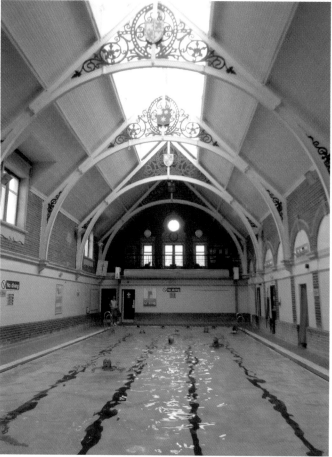

The Baths Interior
Now called Westbury Pool, and believed to be the oldest public pool in the country still in regular use, it is 20 metres long with a maximum depth of 1.7 metres. The cubicles at the side are long gone and the diving platform was removed because the pool is now considered too shallow to dive into. The original iron roof girders display the coats of arms of the town and the Laverton family.

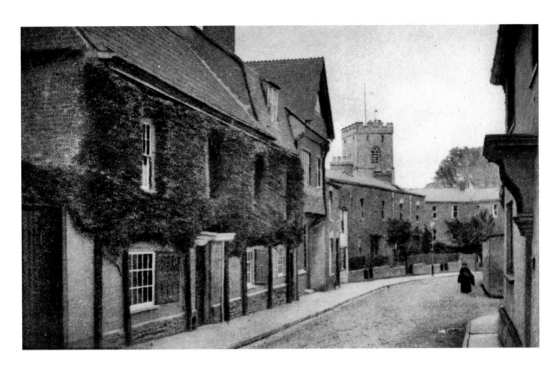

Church Street, 1937

This is one of the older parts of town and today it is a mainly residential conservation area. Ivy House, on the left, has an eighteenth-century frontage on a seventeenth-century house. Next to it, The Gables dates from 1900, and beyond that the houses with railings are Church Terrace, built in the 1820s. To the right of the church tower is part of the range of buildings occupied by Pinniger Finch, solicitors.

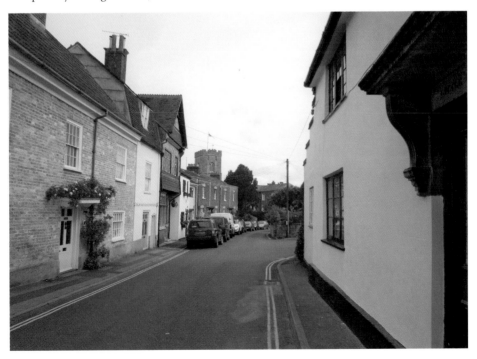

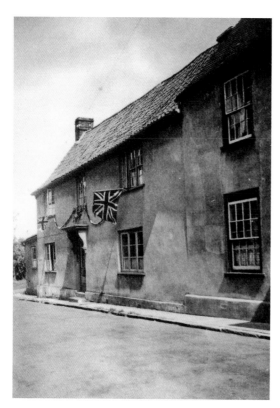

Little Chantry, Church Street, 1945
On early maps Little Chantry is shown as Parsonage Farm, the farmhouse belonging to the manor of Westbury Chantry. The history of the farm can be traced to the twelfth century and the present building has the year 1723 above the door. The flags are out to celebrate VE Day in May 1945.

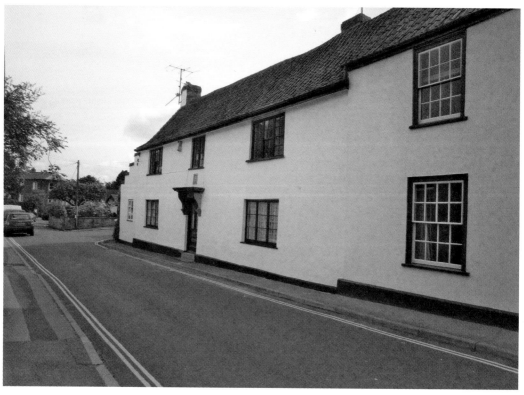

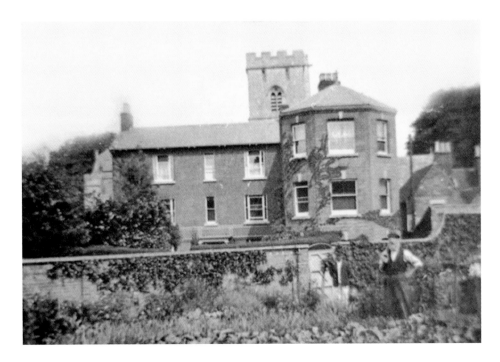

Pinniger Finch, Church Street

This is the home of a law firm set up by Henry Pinniger in 1819. The red-brick wing on the right is from the nineteenth century, but the aspect facing the street has older features including a stone gable end and a decorated window, which may be from the fourteenth century. It was probably the manor house of Westbury Chantry. After the Second World War houses were built on the gardens in the foreground.

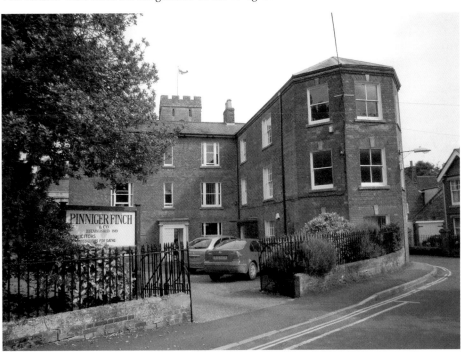

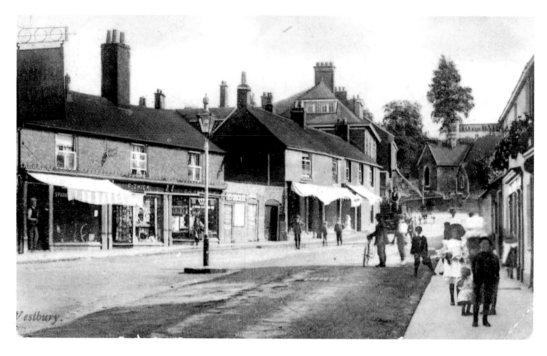

Edward Street Looking Towards Bratton Road, 1908

A wide variety of shops could be found in Edward Street during the first part of the twentieth century, including a china dealer, bootmaker, baker, confectioner, grocer and fancy repository. The shops on the left were rebuilt in 1936 by Mr Hann, a grocer and baker. In 1966 they became showrooms for F. G. Collier & Son, first established in Westbury as a coal and builders' merchants in 1895.

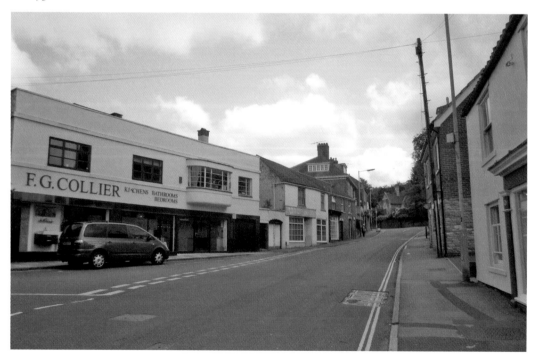

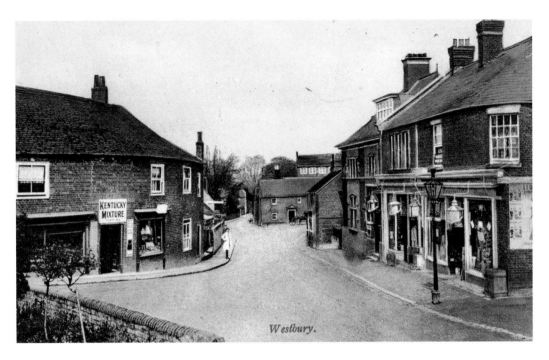

Westbury.

Edward Street Looking Towards the Angel Hotel

Facing up the street, the Angel Hotel can be traced to around 1540 and was a coaching inn during the late eighteenth and early nineteenth centuries. The double-fronted shop (right) was Couzen's and later Butcher's, both drapers. Next to it, what is now Lloyds Bank was built in 1900 as a branch of Capital & Counties Bank. After the shop on the left was demolished, silver birches were planted in 1973.

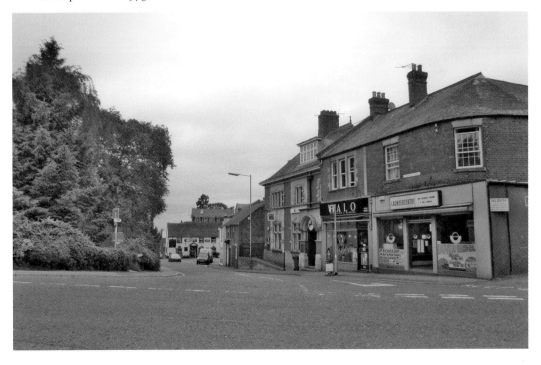

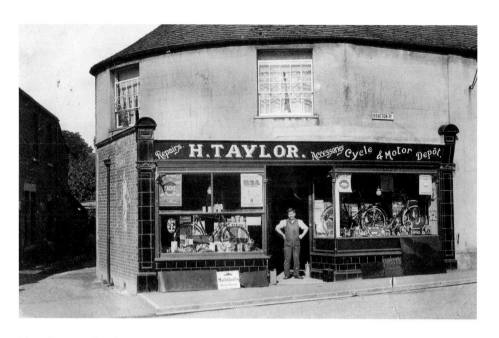

No. 1 Bratton Road

The shop at No. 1 Bratton Road has had a wide variety of uses over the last century. Before Taylor, Martingale was also a bicycle dealer and motor agent. In the 1920s it became a ladies' outfitters and then a draper's. During the Second World War and beyond it was the Westbury Labour Exchange. Since then it has been an estate agency, a print shop and a takeaway. Despite alterations, some of the tiling in the original picture remains.

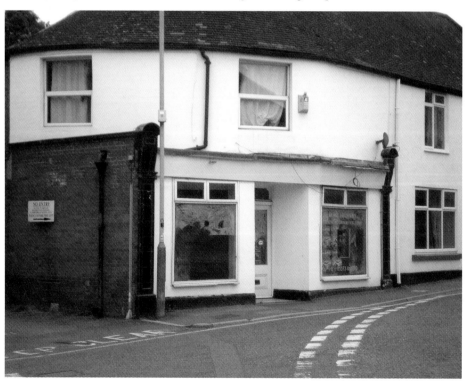

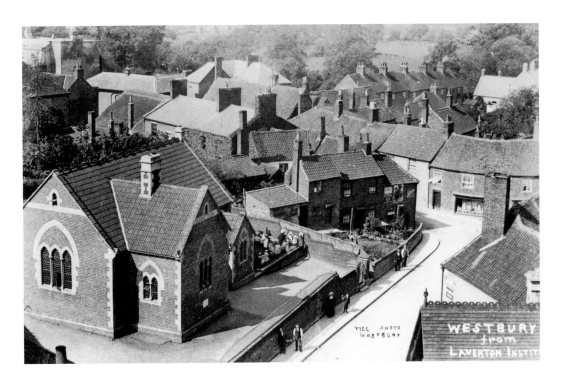

Laverton Infant School, Bratton Road

Funded by Abraham Laverton and opened in 1885, for nearly a century many of the town's youngest children started their education here. The main part housed two classrooms, separated by a wooden folding screen and heated by coal stoves. The toilets were in a separate block in the playground. In 1971, when a new school was built, the old premises were sold and converted into a house.

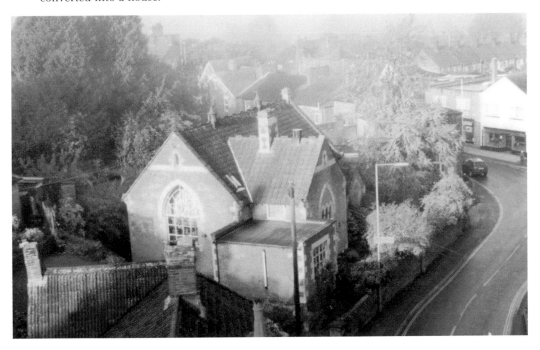

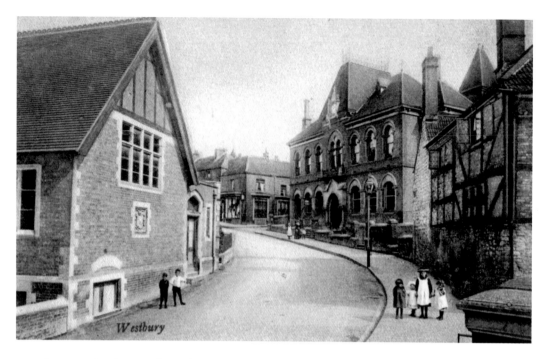

Laverton Institute and No. 6 Bratton Road, 1906

The brick and timber-framed house (No. 6) is possibly from the fifteenth century and is the oldest in Westbury. Next to it, the Laverton Institute opened in 1873 for recreational and cultural purposes. The mansard and illuminated clock were removed after 1920. From 1874 until 1925 a boys' school occupied part of the ground floor. Renamed the Laverton in 1968 and most recently refurbished in 2011, it has meeting rooms, a large hall and the offices of Westbury Town Council.

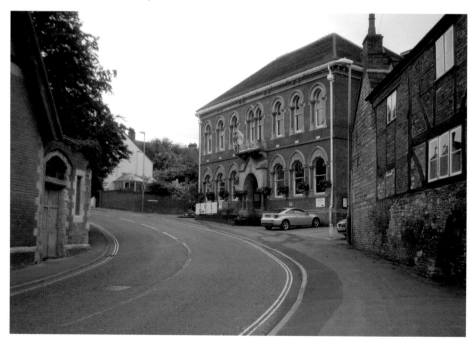

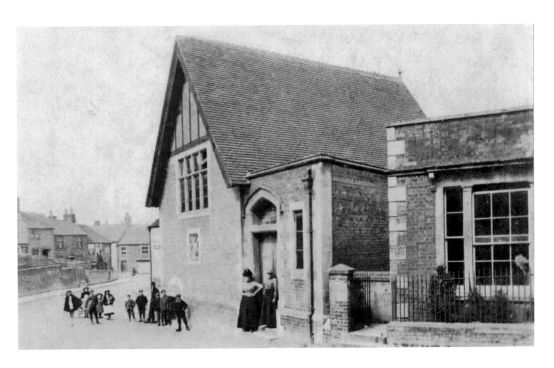

Oddfellows Hall, Bratton Road

Built for the Westbury (Prince Albert) Lodge of the Independent Order of Oddfellows, Manchester Unity, in the 1880s, it has also been used as a second-hand furniture shop and is now a private house. The Oddfellows protected and cared for their members and the wider community in the days before the welfare state, and they were still active in Westbury after the Second World War.

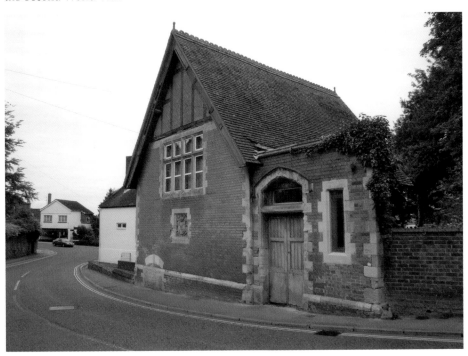

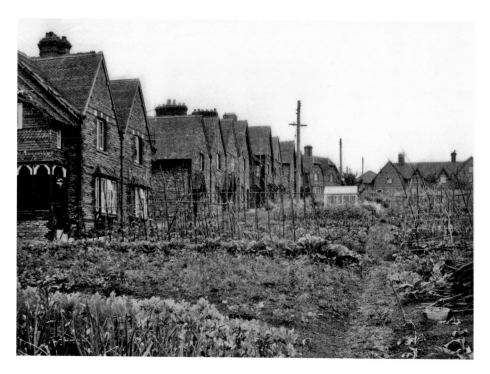

Prospect Square, Bratton Road

A development of thirty-nine houses provided by Abraham Laverton in 1869 as better housing for his workforce and to rehouse voters evicted for choosing the 'wrong' candidate in the 1868 General Election. The top terrace later became almshouses for retired millworkers, supported by the rents from the other tenants. Known as The Buildings by many locals, most of the houses were sold and modernised in 1980, and the allotments were landscaped.

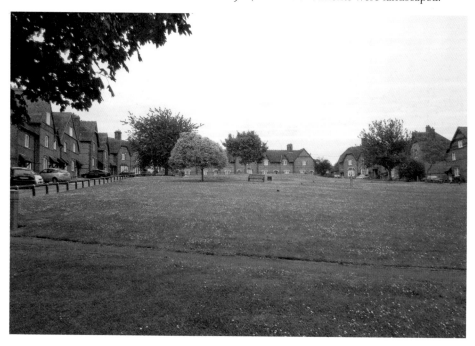

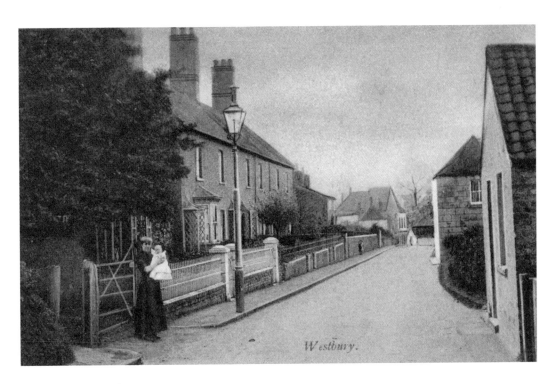

Bratton Road, 1900s

The Laverton Institute is just visible as the road bends and descends to the rest of the town. On the right, the Chantry Lane footpath goes down to Church Street and provides a shortcut to the church. The cottage at the top of the path has gone, but the houses on the left have retained their early nineteenth-century ironwork porches.

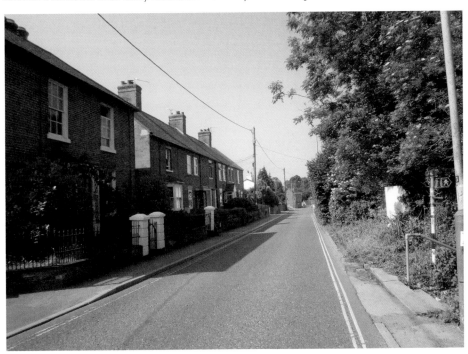

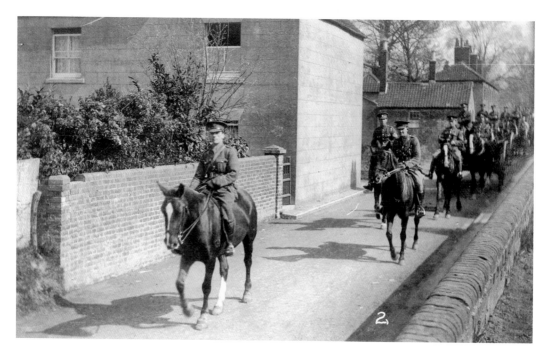

Soldiers in Bratton Road, First World War

From the start of the war soldiers were brought to Westbury and billeted in public buildings and private houses while undergoing training. These men may be returning from the hills or heading to the station to leave for the front. The house on the far left was built in 1923 as the Baptist church manse; otherwise the surroundings are largely unchanged.

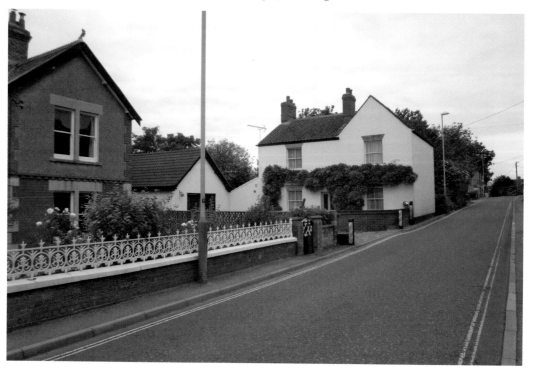

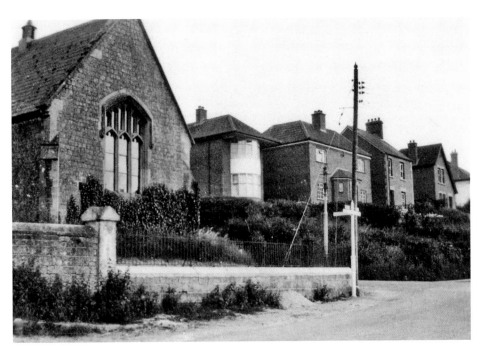

Boys' Schoolroom, Corner of Bratton Road and Newtown

The Church of England Day School was started by the vicar, Stafford Brown, and this schoolroom built to accommodate it in 1847. A few years later the girls and infants moved to another site and it continued as a boys' school. In 1925, separate senior and junior schools were created and the boys moved out. Later used to provide extra space for the infant and then the senior schools, it was eventually sold and became the White Horse Pottery.

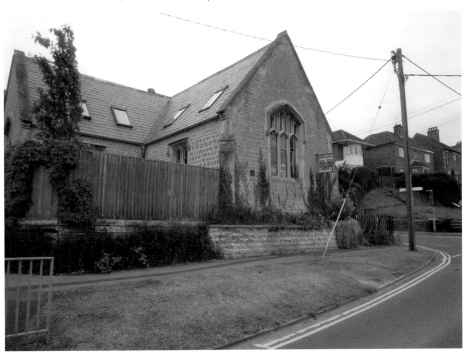

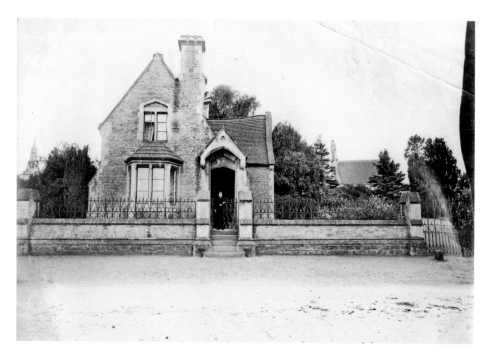

Cemetery, Bratton Road

Around 5 acres of land were bought by the parish in 1857 for a new cemetery, including a house for a superintendent. Within the grounds are two chapels – Anglican and Nonconformist – and mausoleums for the Phipps, Ludlow and Lopes families. In the 1920s and 1930s William Windsor was the superintendent. A monumental mason now uses the lodge as a showroom.

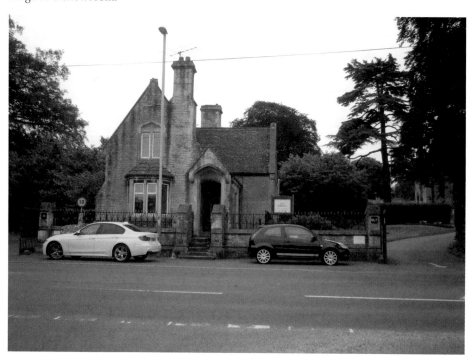

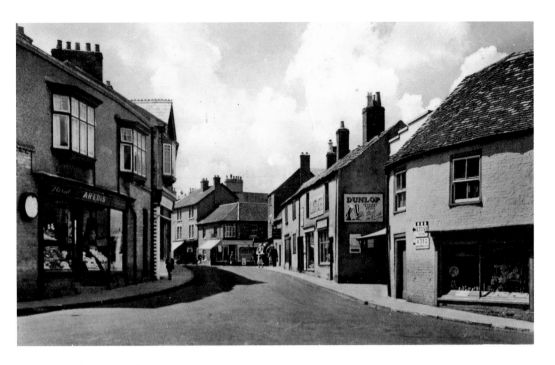

Warminster Road, Late 1940s

Starting at the top of Edward Street, Warminster Road is one of the town's main streets, with a mixture of shops and houses. The partially visible canopy on the right is Norris's shoe shop and next was Mogg's, a newsagent. The cottages of Ivy Court, behind here, were demolished when new shops were built in the 1950s. Fewer shops remain on the left, where there was once a greengrocer, a baker and two butchers.

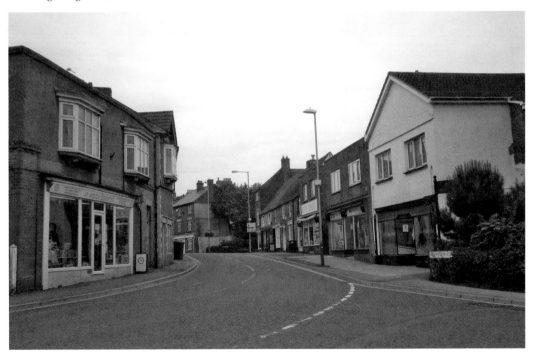

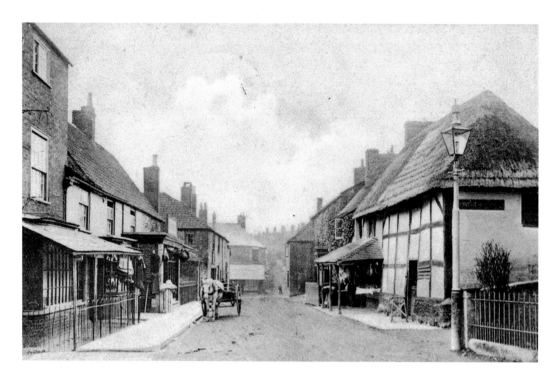

Warminster Road, 1905

At the busy junction with Haynes Road, Warminster Road becomes the A350. The horse and cart are outside Mr Marks' shop, which later became the Witches' Cauldron café; parts of the building date from the sixteenth century. The thatched building, probably of a similar age, was demolished in around 1909. Mr Bull, a butcher, traded here and in its red-brick replacement. The shop remained a butcher's for most of the twentieth century, later kept by Mr Elkins.

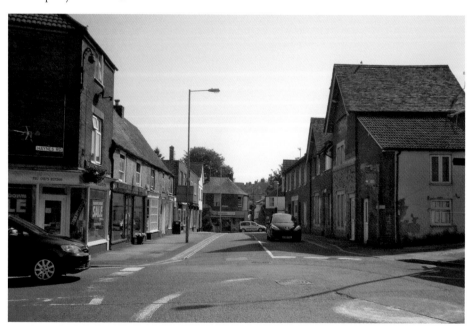

Sweet Shop, Corner of Warminster Road and Haynes Road, 1929 Under various owners this was very familiar to generations of Westbury children. Known as Batten Café in the 1930s, the tea rooms had gone by the 1960s when the shop was owned by Mr and Mrs Gray. It was demolished in the late 1970s to widen the junction and allow a mini-roundabout to be installed.

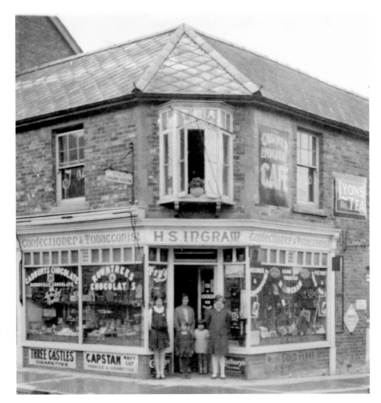

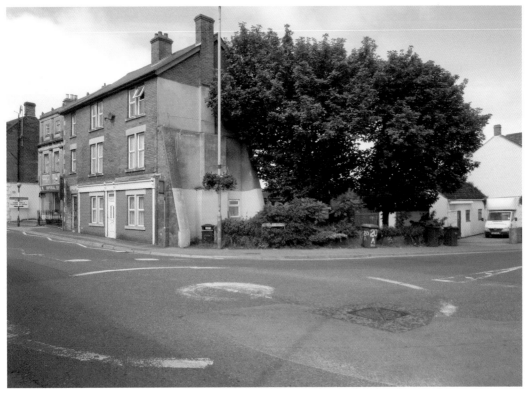

49

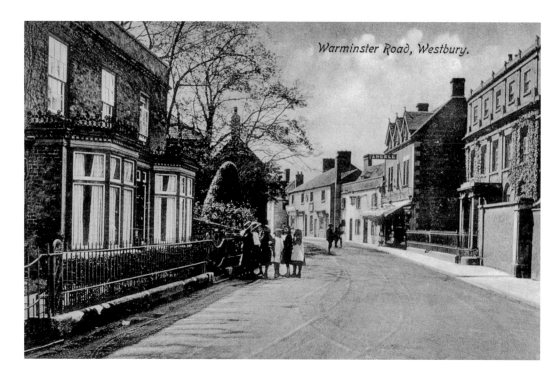

Warminster Road, Westbury.

Warminster Road, 1900s

Eighteenth-century Bella Vista House (right), with its gardens opposite, was once owned by the Haynes family who, in 1820, caused the lane beside it to be moved 15 yards eastwards to its present position as Haynes Road. Angell was a boot- and shoemaker, and was still in business in the 1930s. After several later uses, including a fishmonger, boutique and antique shop, this building is now a Thai restaurant, and still retains its decorative ironwork.

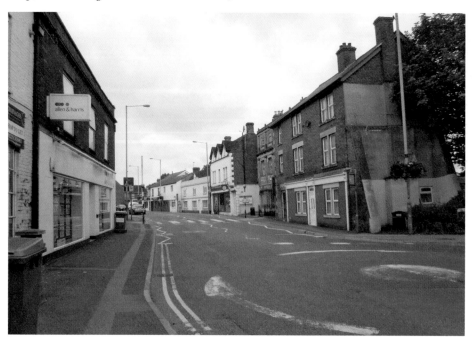

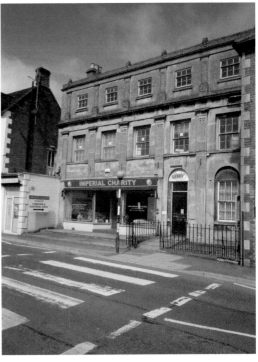

Bella Vista House, Warminster Road, 1914
At the start of the First World War soldiers were billeted here. On the back of the original postcard one young volunteer has written, 'This is the first billet to which we went on arrival at Westbury 20.12.14. Please keep this safe.' By the 1940s it had been converted into Collier's ironmongers, with a glass canopy over the front area where goods were displayed. After some years as offices for a firm of solicitors, it is now a charity shop.

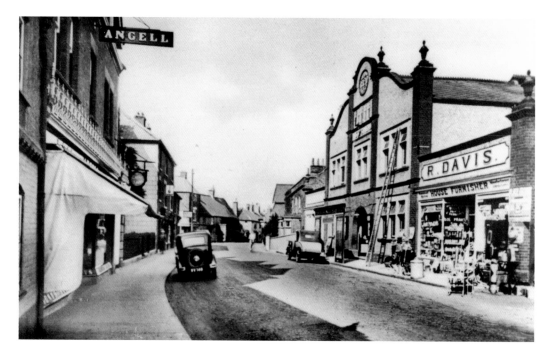

Vista Cinema, Warminster Road, c. 1930s

Opened in 1920, the Vista was an ex-Army building, formerly used as a cinema for troops in Sutton Veny. It was relocated here with the addition of a brick frontage and a shop each side. A notable feature inside was the balcony, two steps up from the stalls. Despite its prefabricated construction, it served the town for over sixty years. By the 1970s the decline in cinema-going led to its use as a bingo hall several evenings a week.

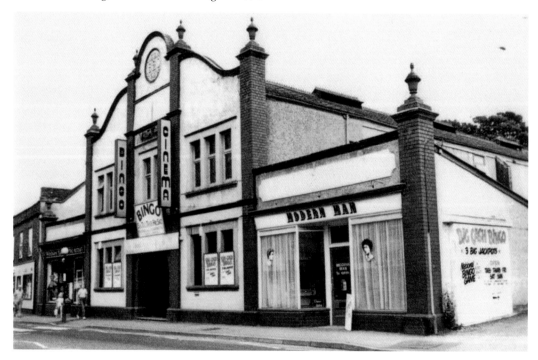

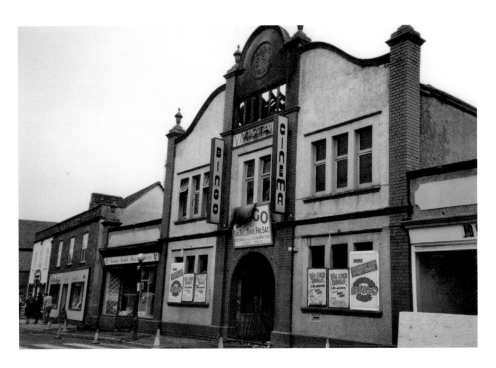

Vista Cinema, 1988

Over the Easter weekend in 1988 the cinema was destroyed by fire, the glow of which was clearly visible in the night sky over a large part of town. The site remained undeveloped for several years until it was bought by the Laverton Housing Trust to provide homes for older residents. Vista Court was completed in 2001.

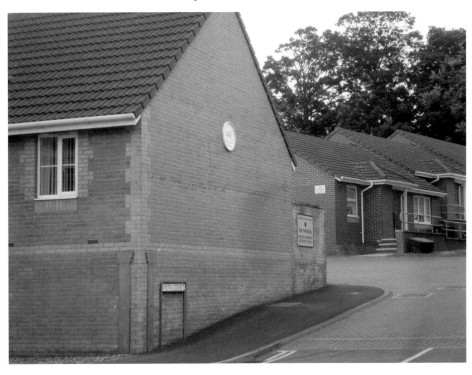

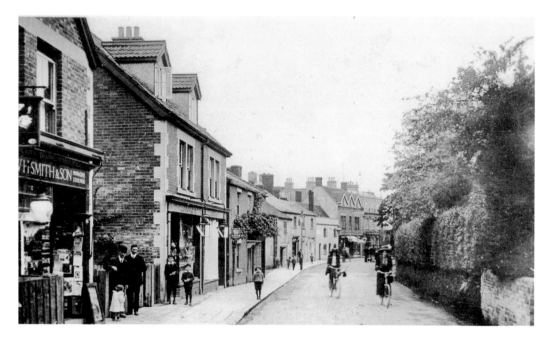

WHSmith, Warminster Road, 1900s

On the left little has changed. A car park entrance replaces the demolished buildings and beyond that a small supermarket and Cutler's grocery are among previous occupants of what is now a Chinese restaurant. The lower white building near the centre was the George Inn and opposite was the Westbury Brewery. Smith's left the town in the 1960s, but the shop continued to be a newsagent's for several years. Most recently it has been an estate agency.

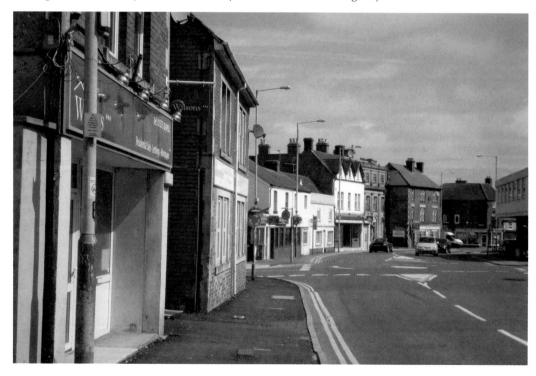

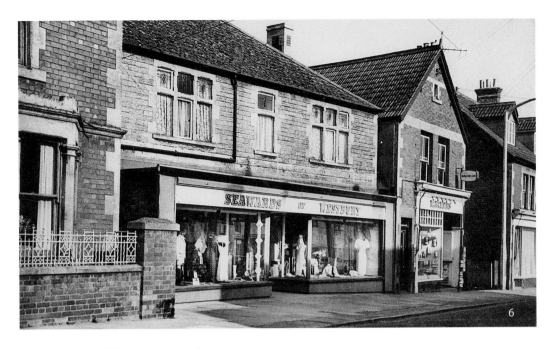

Seawards, Warminster Road, 1960s

First established in Bratton Road in the 1920s, Mrs Seward's dress shop had moved to larger premises in Warminster Road by the 1930s. The family-run business continued until the 1970s and then the shop became a small supermarket. The shop frontage has now gone and the building has been converted into flats. The house on the left was demolished so the Oval Motor Company could expand. Now an Aldi store occupies this site.

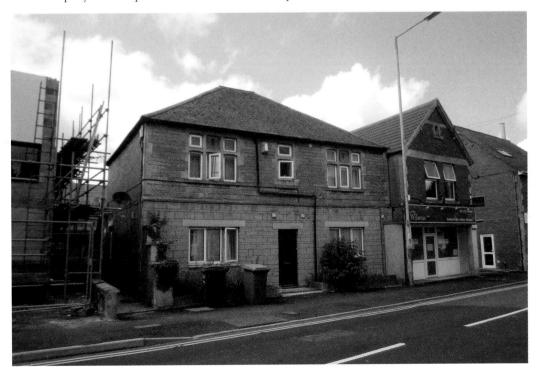

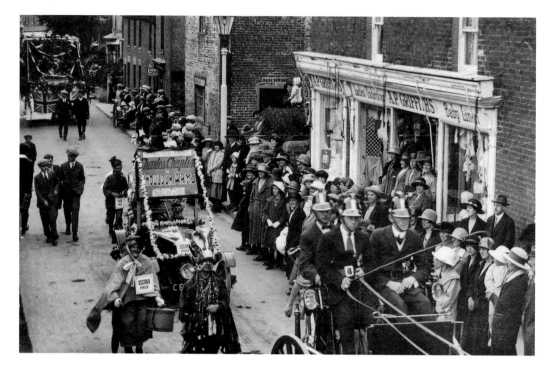

Carnival in Warminster Road, Early 1920s

A carnival to raise money for the hospital was a regular event in Westbury until the Second World War. Griffiths' shop was later owned by the Cripps family. It was subsequently a dress shop and then a hairdresser's before being converted to housing. The Charlie Chaplin film was released in 1918 and must have been an early attraction at the Vista Cinema.

Old Congregational Church, Warminster Road, 1905

Founded in 1662, the present church was built in 1821 at a cost of £2,000, on or near the site of a previous chapel. The iron gates are a notable feature and there is a disused burial ground to the right of the path. In 1972 Congregationalists joined with the Presbyterians to form the United Reformed Church.

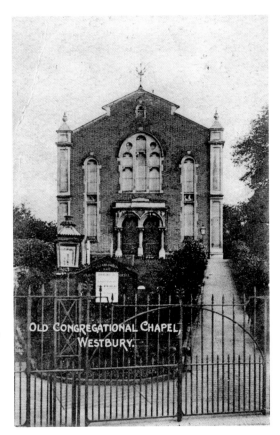

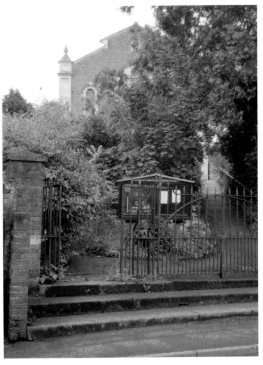

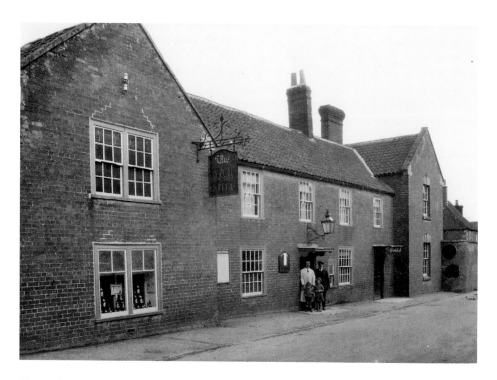

The Oak Inn, Warminster Road, Early 1930s

Part of a complex of buildings, which included a brewery in the nineteenth century, the Oak Inn was run by the Hartshorn family for around seventy years until 1960. When the pub later closed, the building became offices for the adjacent Oval Motor Company. The site was bought by Aldi and cleared in 2012. During demolition, roof beams were discovered, suggesting part of the building was of medieval origin.

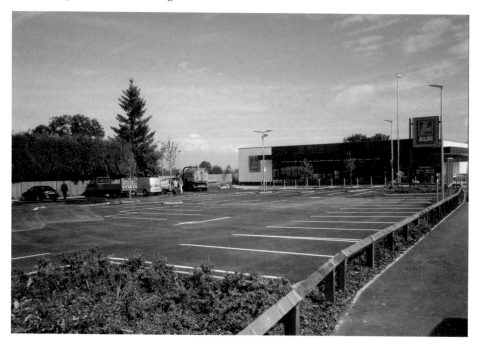

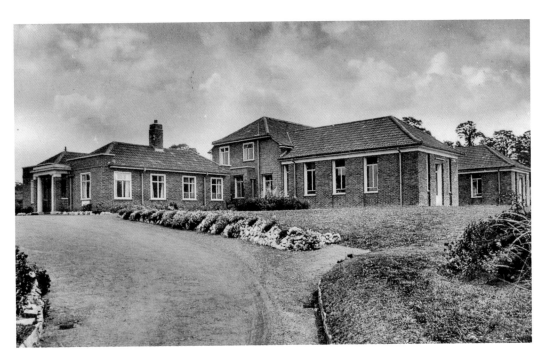

Westbury and District Hospital, Hospital Road

Funded by the town's residents, building started in 1930 and the hospital opened the following year. Absorbed into the National Health Service in 1948, local fundraising by the League of Friends continued to play an important part and provided day rooms and equipment. After being closed to inpatients in 2006, it continued as a doctors' surgery until 2012 when the site was put up for sale.

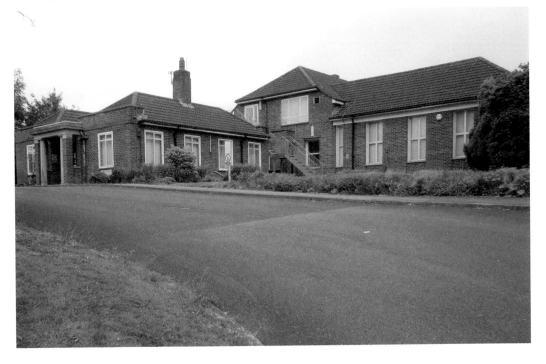

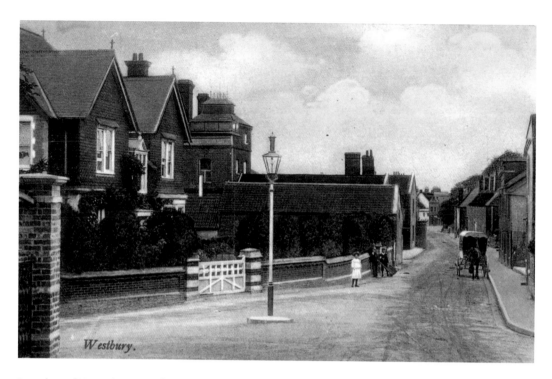

Westbury.

Junction of Warminster and Leigh Roads, Looking Towards Town, 1900s
Several substantial turn-of-the-century family homes stand at or near this crossroads, once known as Town End. Leigh (formerly Lower) Road turns off on the left. The square tower belongs to the Oak Inn complex, and was once Mead's brewery, with a malthouse behind. Part of the building was used as a glove factory until the beginning of the current century.

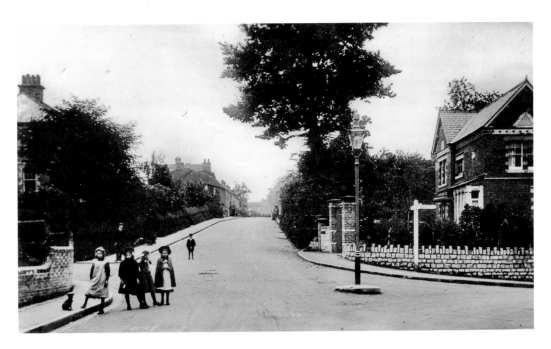

Junction of Warminster and Leigh Roads, Looking Away from Town, 1900s
On the right, Stanley View was built in 1904 and has decorative tile work in its gable. The turning on the left is now Hospital Road, but was formerly Dowdens Lane. From here, Warminster Road rises gently past cottages and some larger houses, until the house facing down the road, at the junction with Wellhead Lane.

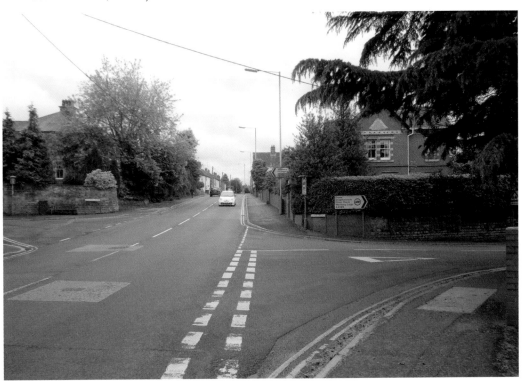

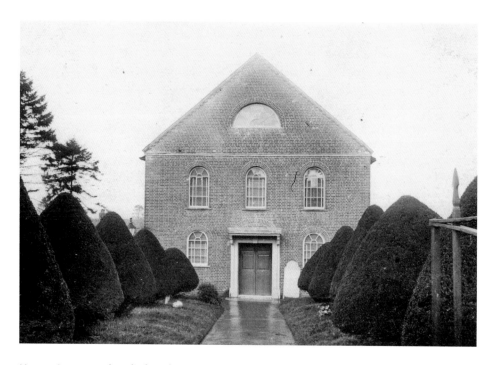

Upper Congregational Church, Warminster Road

In 1751 a division occurred among members of the church and part of the congregation left to worship elsewhere. In around 1790 they built a new church further up Warminster Road. The two churches remained divided until 1940. This building was then used as a furniture store for several years. It is now listed and was converted into houses in 1988.

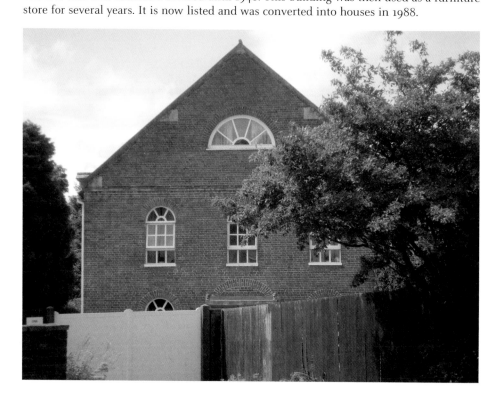

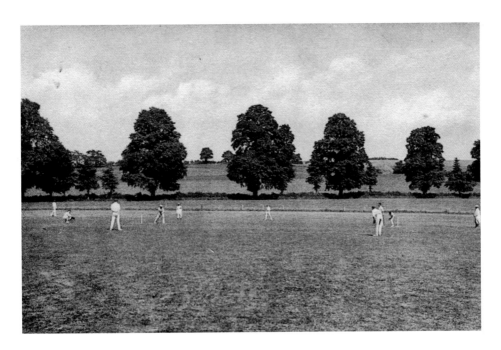

Cricket Field, Wellhead Lane, *c.* 1920s
Laid out in 1892 as part of the Leighton House estate, the field was used by boys from Victoria College from 1921 until 1936. The grounds included a pavilion and squash court. In 1945 it became the home of the reformed Westbury & District Cricket Club, which still plays there today. Now known as Leighton Recreation Centre, the area was increased by adding two adjoining fields. The trees on the boundary were lost to Dutch elm disease in the 1970s.

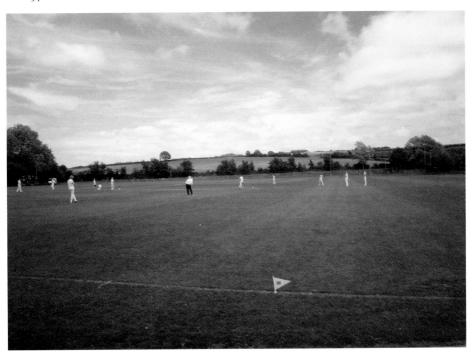

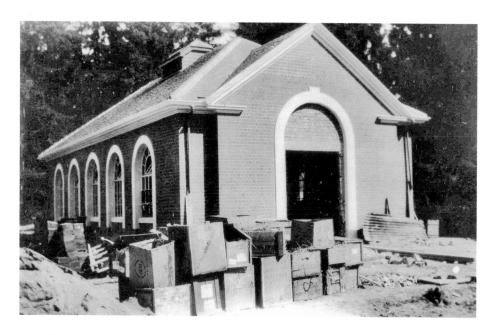

Pumping Station, Wellhead Drove, 1929

The chalk hills above the town are a natural aquifer and many streams start at the springline at their base. In the early twentieth century, work was done to provide mains water to the whole town, and in 1929 the pumping station at the bottom of Grassy Slope was built to extract water from the Wellhead stream. The Westbury & Dilton Marsh Joint Water Committee once employed a full-time engineer at the site. Now it is part of Wessex Water's network.

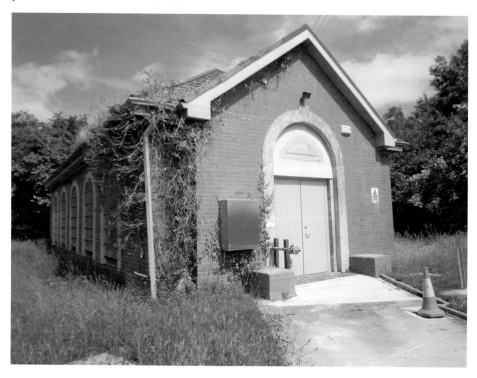

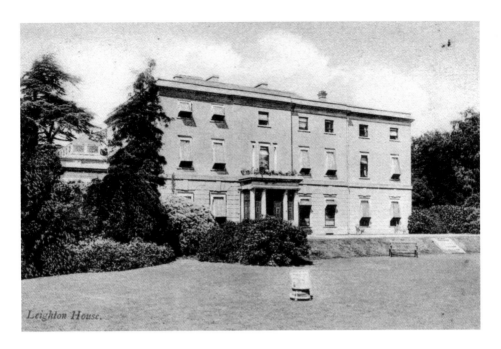

Leighton House, South Front, *c.* 1920s

Leighton House was originally built in 1800 by Thomas Henry Hele Phipps, and then sold to William Henry Laverton in 1888. He remodelled the interior and extended the house, adding the east wing (right) and the conservatory (left). It remained his home until 1921, when he sold the estate to Victoria College, a boys' boarding school. In 1936 the house failed to sell at auction and remained empty until requisitioned for use as an Army convalescent hospital during the Second World War.

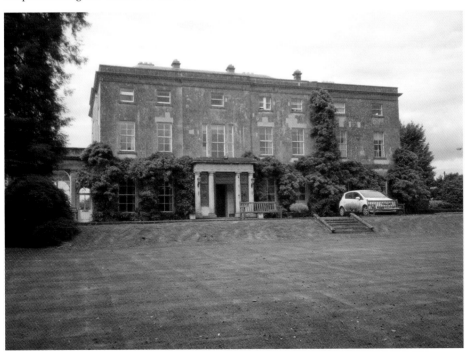

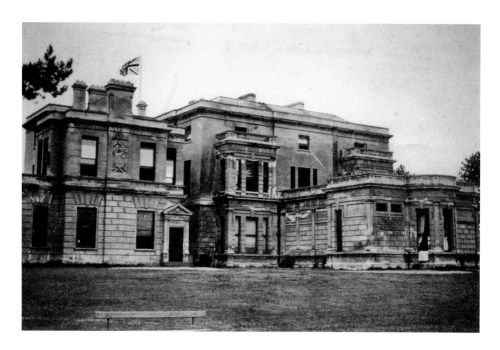

Leighton House, Rear Elevation

The rear of the house shows more of the additions made by W. H. Laverton, including the single-storey extension built as a billiard room. The family's coat of arms is carved between the two windows on the left. In 1949 the house and most of the estate became home to the Regular Commissions Board (now the Army Officer Selection Board) where potential officers are assessed.

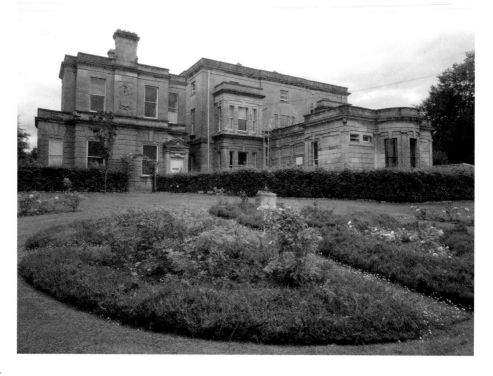

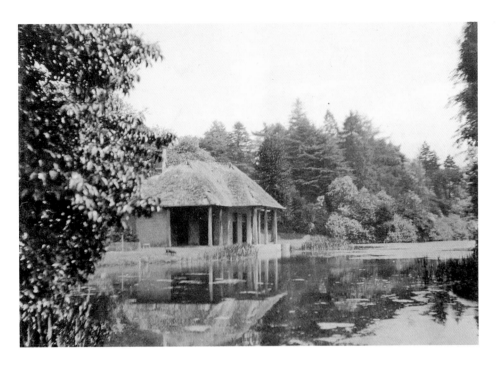

Boathouse and Lake, Leighton House

To the south of the house and just within the perimeter wall, the lake was probably originally a millpond fed from the Wellhead stream. Ball's Mill was one of two fulling or grist mills within the grounds. At one time a large waterwheel pumped water up to the house. Although the boathouse has gone, its footings and the two inlets for boats are still visible.

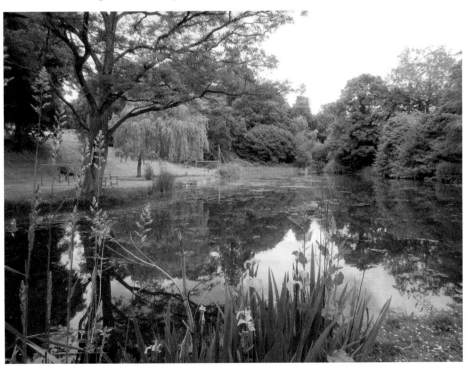

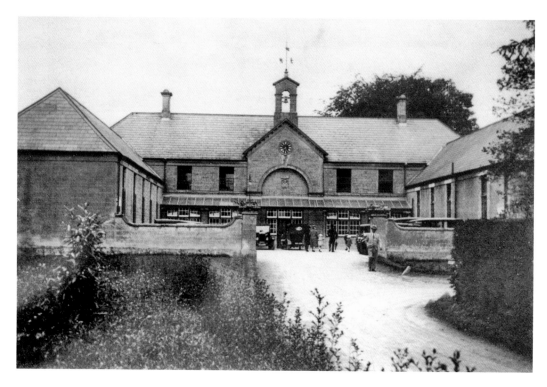

Stables, Leighton House

Built at the same time as the main house, but on the part of the estate on the eastern side of Warminster Road, the central clock is an original feature. During its use as a school the building was converted to house classrooms.

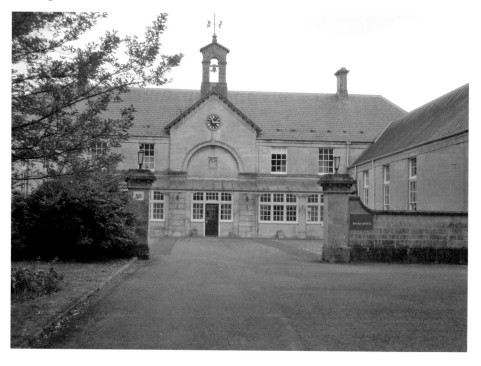

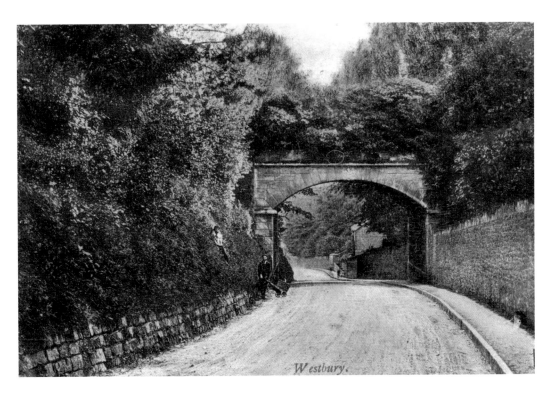

Bridge Over Warminster Road

The Leighton estate is divided by the Warminster Road, so W. H. Laverton joined the two parts with a bridge to provide easy access from the house to the theatre he had also built. When the road was widened in 1976, the original stone bridge was replaced and some cottages were demolished. The road descends from here to Chalford, before rising again to the junction with Wellhead Drove and the Old Dilton Road at the edge of town.

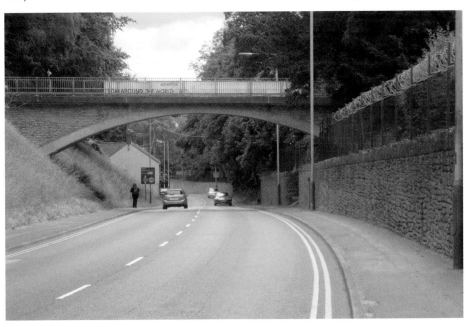

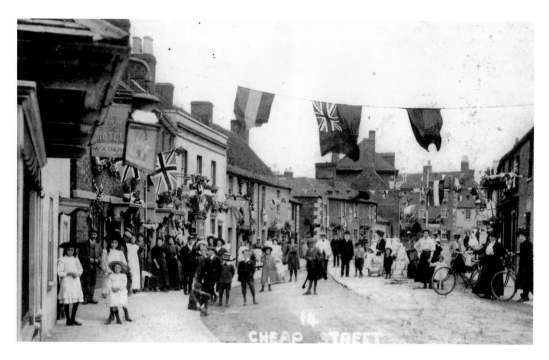

Cheap Street (Now West End), *c.* 1900

West End now runs from the Market Place to the junction of Haynes Road and Station Road. When this picture was taken it was developed only at the Market Place end. The Wheatsheaf Hotel on the left is now housing; in the late nineteenth century it included a butcher's shop, a slaughterhouse and a brewery. The reason for the celebration is not known – could it have been the end of the Boer War?

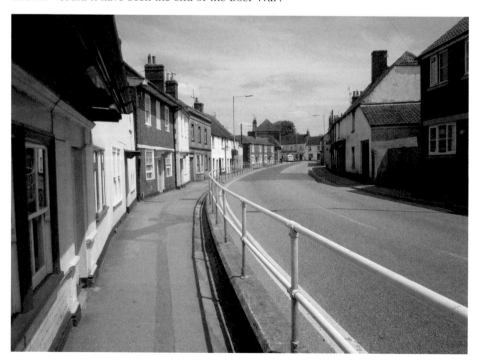

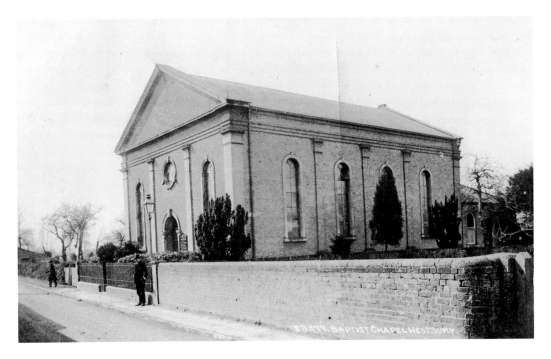

Baptist Church, West End, c. 1900

The first church was licensed in 1824 and extended in 1853. A decade later the growth of the congregation required a larger building and the present church was opened in 1868. The railings and hedge at the front have since been removed. The Drill Hall is behind the railings to the left of the church and houses have been built beyond that.

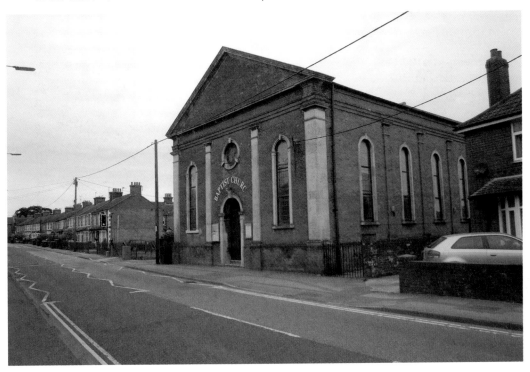

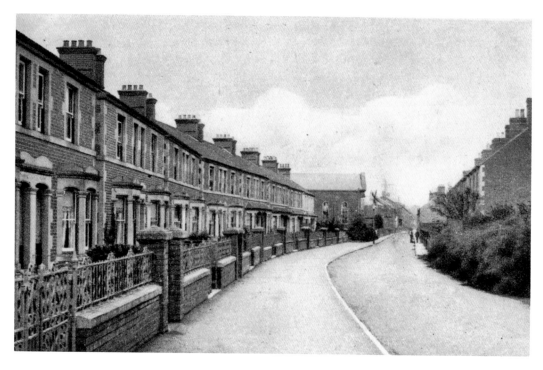

West End, *c.* 1910

After several name changes, this became West End around the time the houses on the left were built. Some still retain the original Art Nouveau porch tiles. The railings avoided removal during the Second World War, apparently because the men detailed to carry out the job in 1943 were reassigned to work on bomb-damaged buildings elsewhere. The houses opposite are slightly older.

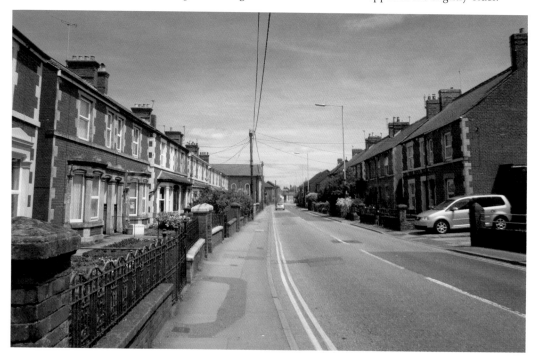

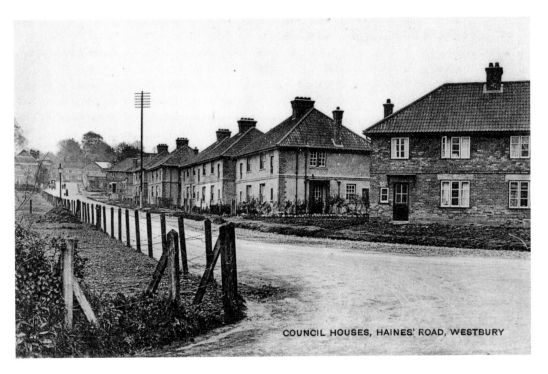

COUNCIL HOUSES, HAINES' ROAD, WESTBURY

Council Houses, Haynes Road, *c.* 1920s

Originally Haynes Lane, the name was changed shortly before the First World War. These were some of the first council houses built, part of a larger development including The Crescent and The Avenue. They were modernised and converted to flats for the elderly in 1971, when it was recorded that one tenant had lived there for over fifty years. Two shops, houses and the Prideaux Hospital (now the Labour Club) were soon built on the left-hand side.

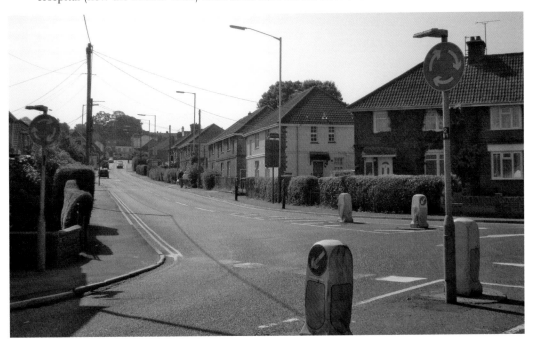

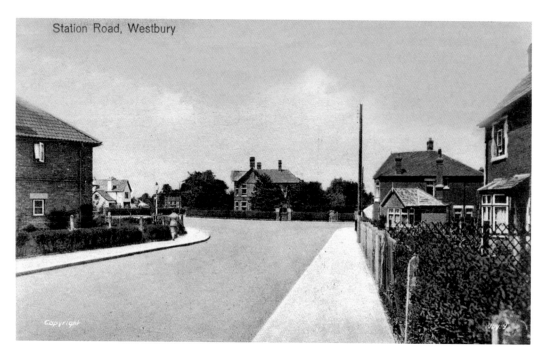

Station Road, Westbury

Junction of Station Road, Haynes Road and West End, c. 1920s
The White House (left) was the home and surgery of Dr Mary Prideaux. In the centre, Eastleigh became the town's doctors' surgery in 1957 and was much extended over the years. The doctors moved out to the new health centre in 2012 and the site is awaiting a new owner. On the far right, the Red House faces the junction; it was once a shop, and is now a house. The Methodist church (on the left in the modern picture) was opened and dedicated in 1926.

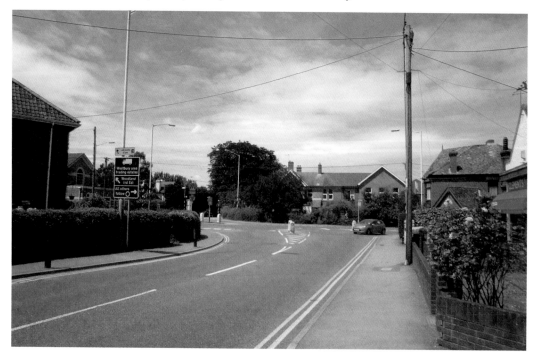

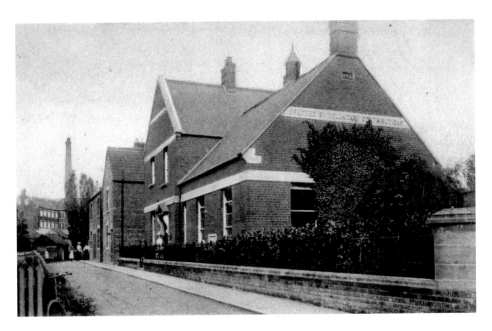

Hospital, Westbourne Road, Off Haynes Road

Around £600 was raised through voluntary subscriptions to build the town's first hospital in Bourne's Barton and commemorate Queen Victoria's Diamond Jubilee in 1897. The original building had four beds, and was later enlarged to accommodate ten patients. When the new hospital opened in 1931, the redundant building became three houses. Bourne's Barton, which had been renamed Hospital Road, then acquired its present name, Westbourne Road.

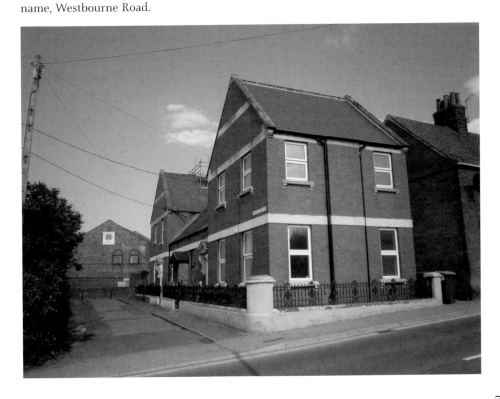

Station Road at its Junction with Eden Vale Road

One of the longer roads in Westbury, the part shown in the picture was once known as Grass Acres Road, while the section from here to the station site was Perry Way. The men are standing at the corner of what is now Meadow Lane, a post-war housing development. On the same corner were the offices of J. T. Parsons & Son, a local building firm. The buildings on the right include the police station, built in the 1930s.

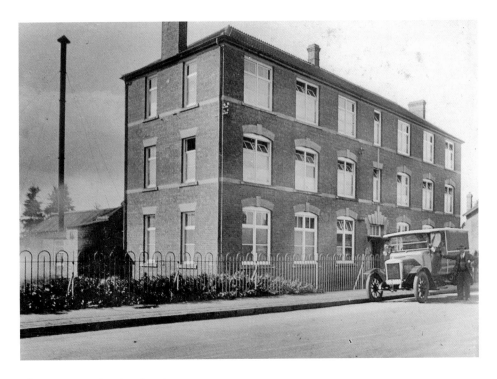

Glove Factory, Station Road

For over a century, glovemaking was an important industry in the town, carried out in several locations and by outworkers at home. This factory was built in 1908 and used by J. P. Boulton and later by the Westbury Glove Co. Ltd. Cheaper foreign imports led to a decline in the industry and the factory closed in 1960. It has since been converted into flats and is called Orchard Hall.

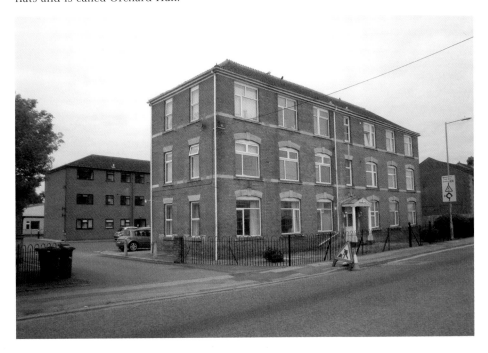

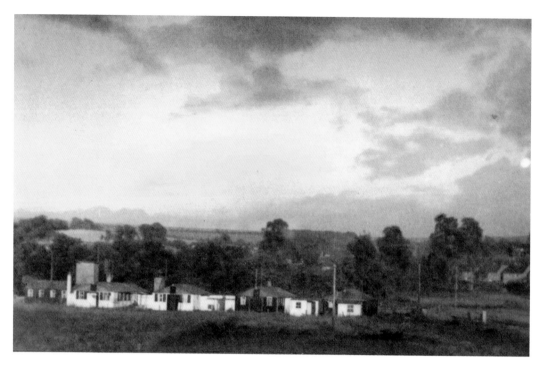

Prisoner of War Camp, Oldfield Road

At one time during the Second World War there were at least two prisoner of war camps in the town. Built in 1943, Italians were its first residents, followed by Germans from 1945 until spring 1948. It was then used as local authority housing while the new Oldfield Park estate grew up around it. Today the area is completely changed; only the shape of the hills in the background provides a point of reference.

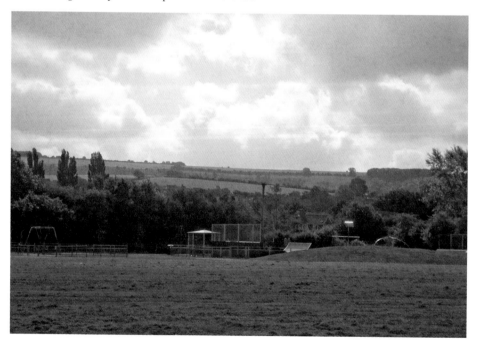

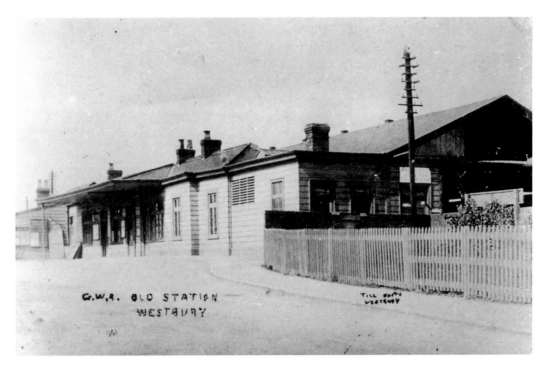

Westbury Railway Station, 1899
Westbury became a railway town in 1848 when a line was opened connecting the town through Trowbridge to Bristol. Within ten years the line had been extended to Salisbury and Weymouth, but it was not until 1901 that passengers could travel to London. The original station with its roof was demolished in 1900 and replaced with the layout that remains today. The platforms, above road level, are approached by a foot tunnel under the tracks.

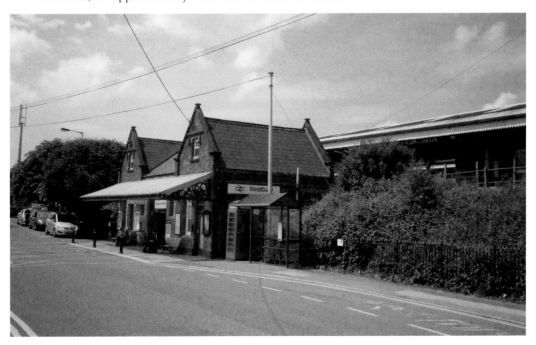

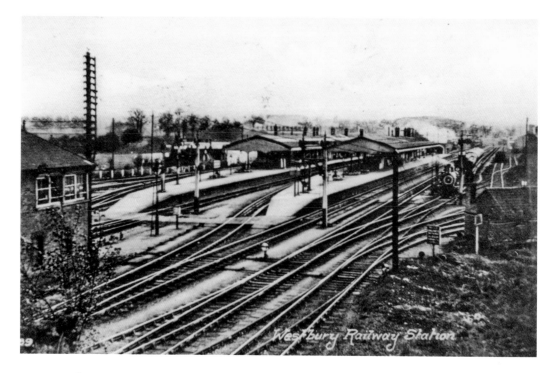

Westbury Station and North Signal Box

As a railway junction, Westbury station is larger than others locally, with platforms long enough to accommodate intercity trains. The north signal box was closed in the 1970s when the signalling system was upgraded. In 1985 the station was updated, although the 1900 layout was retained. The tracks going off to the right provided access to the ironworks.

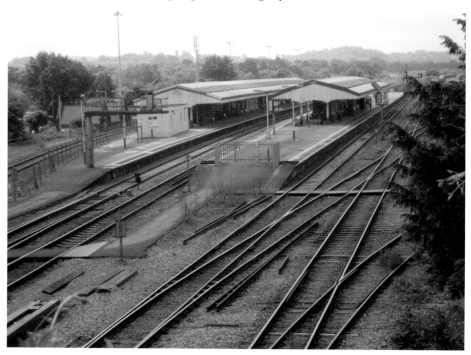

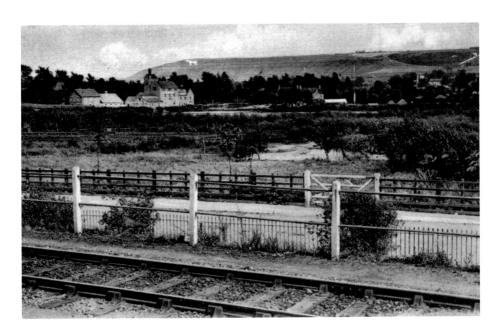

Station Minehole and Railway Inn

Around the area of the station are a series of lakes referred to locally as 'mineholes'. These are the flooded remains of opencast mining for iron ore when the ironworks was in production. Although some have been filled in over the years, the two largest remain; they are now used for fishing and by the West Wilts Youth Sailing Association. In the older picture the Railway Inn is on the far left and had the last brewery to close in the town.

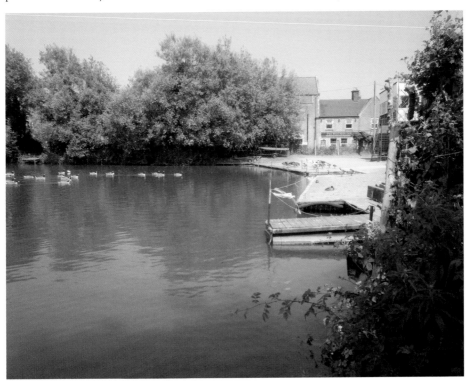

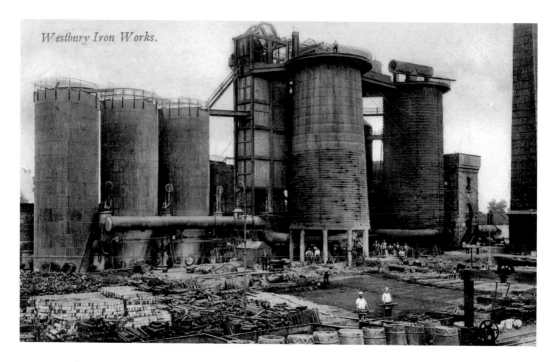

Westbury Iron Works.

Westbury Iron Co.

During construction of the railway, iron ore deposits were discovered and a company formed to exploit this. Opening in 1858, it mostly prospered until a period of decline led to a brief closure. It reopened before the First World War, finally closing in the late 1930s, when the works were dismantled and sold for scrap. Taken over by the civil engineering firm A. E. Farr, the site is now an industrial estate; the Ironworx gym is a reminder of its former use.

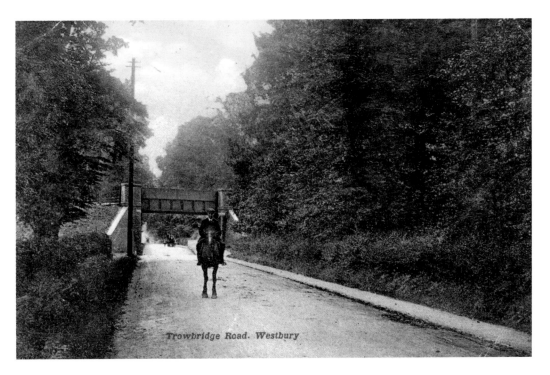

Trowbridge Road. Westbury

Trowbridge Road, Early 1900s

On the northern edge of town the London line crosses the road to Trowbridge. The original bridge has been replaced, but the road underneath still occasionally floods after very heavy rain. The new line meant that 'Buffalo' Bill Cody's Wild West Show could visit in July 1903 and set up in a field just beyond the bridge.

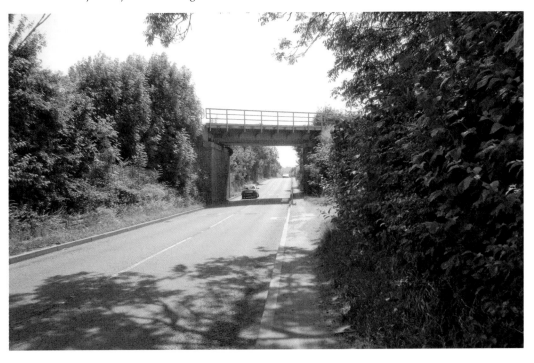

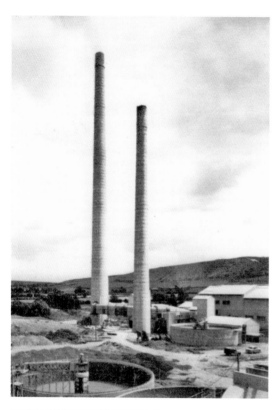

Blue Circle Cement Works, 1965
First opened in 1962, production doubled
in 1965 when a second kiln was installed,
the taller chimney was built and the
first chimney demolished. The company
was taken over by Lafarge in 2001 and
production continued until the plant was
mothballed in 2009. It remains in use as
a distribution depot. The social club has
become the White Horse Country Park;
in 2012 it hosted the Village Pump Folk
Festival for the first time.

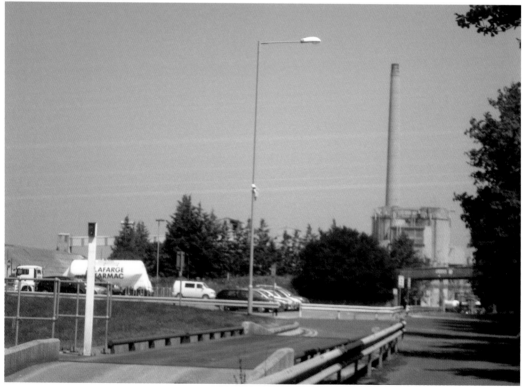

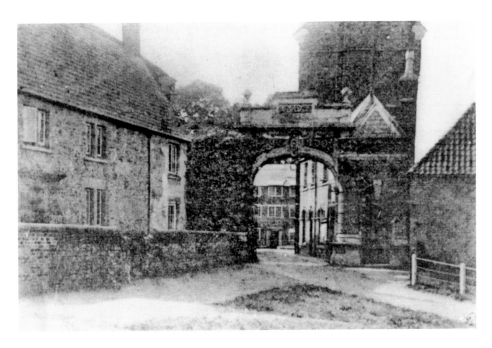

Town Farm and Bitham Mill, Alfred Street, 1921

Farmed by the Scull family for most of the last century, a new farmhouse was built on Bratton Road in 1936 and the old one (left) was demolished allowing the mill to expand onto the site. The original Bitham Mill was built in 1803 and became part of the Laverton company in 1857. After the mill closed, other companies used the site. Some buildings were demolished and replaced by houses in 1999.

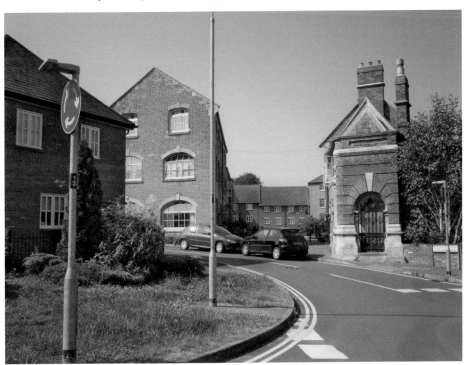

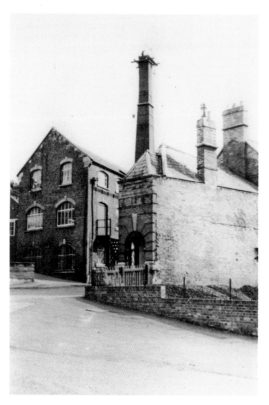

Bitham Mill, Alfred Street, 1950s
During the middle of the twentieth century, the mill buildings were adapted to introduce modern production techniques. The range on the right lost its top two storeys and the arched gateway was removed. The timekeeper's house (centre) was retained and is now a private house, as are the other buildings that survived. Men can be seen working on the chimney, now demolished.

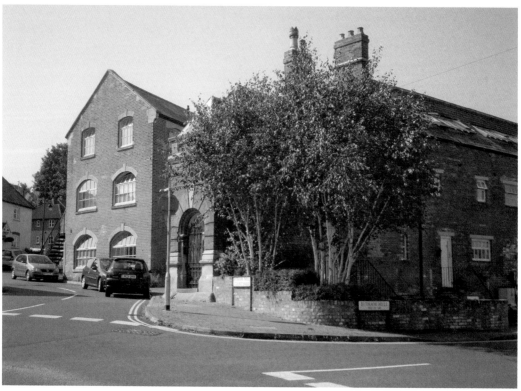

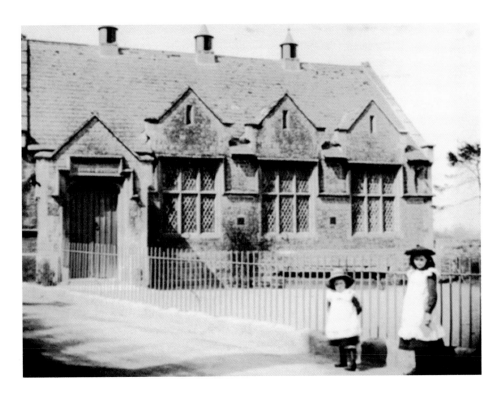

Leigh Road School

Originally built for girls and infants in 1844 and funded by the Matravers bequest, Leigh Road was later a British (Nonconformist) school. In 1925 it became the senior school for older children and the red-brick buildings were added. From 1946 it was the Westbury Secondary Modern School, and a new block accessed from Springfield Road provided more classrooms, a hall, a dining room and a gym. Becoming comprehensive in 1974, it was renamed Matravers School.

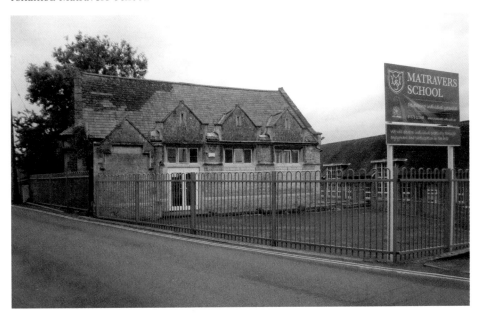

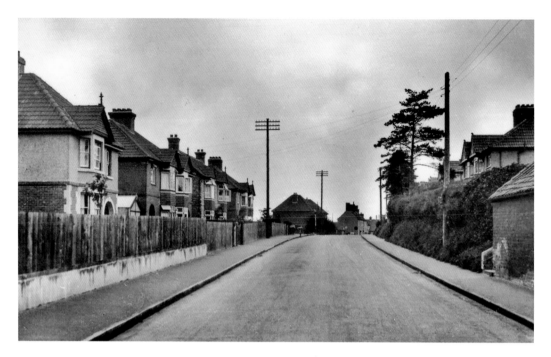

Leigh Road

Linking the town with Westbury Leigh, Leigh Road is wholly residential, with most houses built during the last century. At one time there was a small shop and sub-post office on the left. Beyond the junction with Eden Vale Road it follows the boundary wall of Leighton House estate. Further on is the entrance to the Leigh Park development, where a new road diverts through traffic from Westbury Leigh.

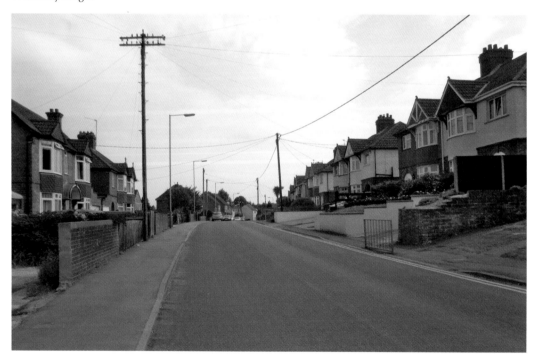

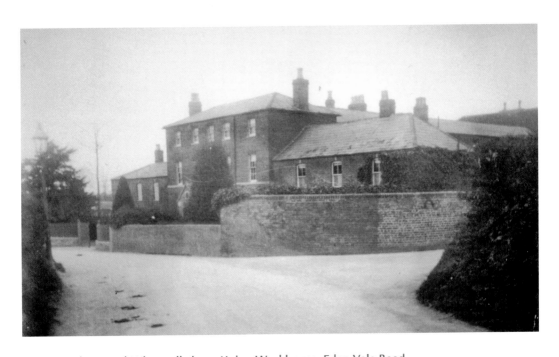

Westbury and Whorwellsdown Union Workhouse, Eden Vale Road
The first workhouse was built in 1769, and partly demolished and rebuilt in 1813. By 1836 an extension was needed to provide accommodation for 300 people. For most of its history it was in a rather isolated part of town with few other buildings close by. After closure in 1930, it became the headquarters of T. Holdaway & Sons, a local building firm. Since the start of the present century it has been William House Court, providing housing for the over-fifties.

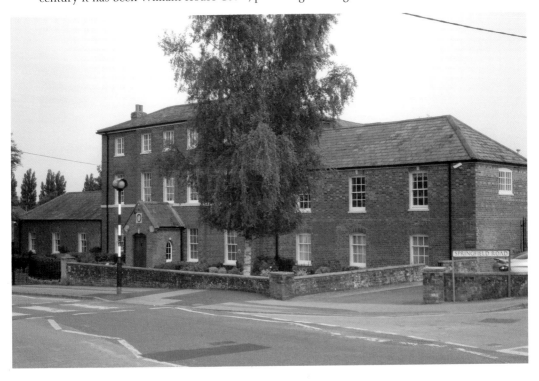

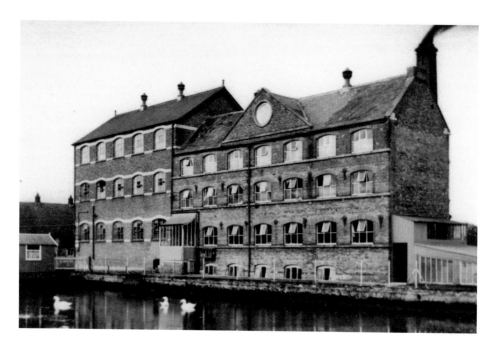

Boulton's Glove Factory, School Lane, Westbury Leigh

The right-hand side is known as Bull's Mill and was built in 1792 as a cloth mill, later converted to corn milling. It was bought by William Boulton in 1901 and used as a glove factory; when the left-hand section was added. The older building was demolished in 1969. After Boulton's closed, Beck's Mill, as it was now called, was used by other firms. When Leigh Park was developed, the former factory was converted to flats.

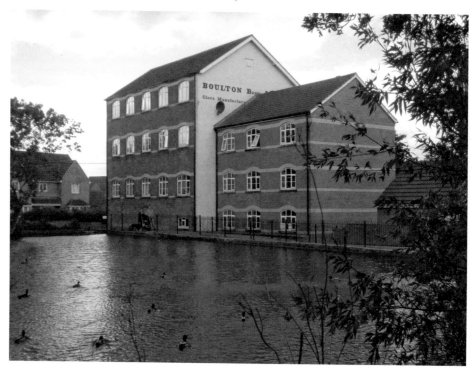

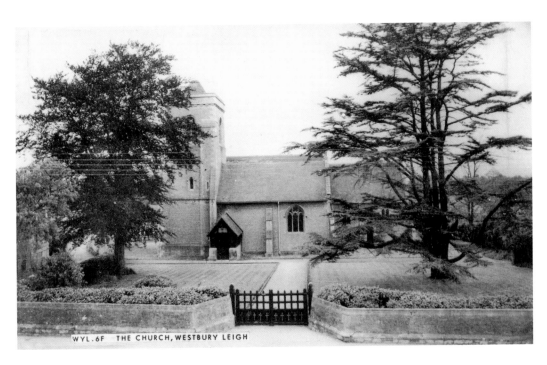

WYL.6F THE CHURCH, WESTBURY LEIGH

Church of the Holy Saviour, Westbury Leigh

Opened in 1877 after an appeal for funds, the church is a chapel of ease in the Westbury parish. The tower was added around ten years later in memory of Richard Phipps. In 2000, the nave was converted for use as a community hall, with regular worship continuing in the chancel.

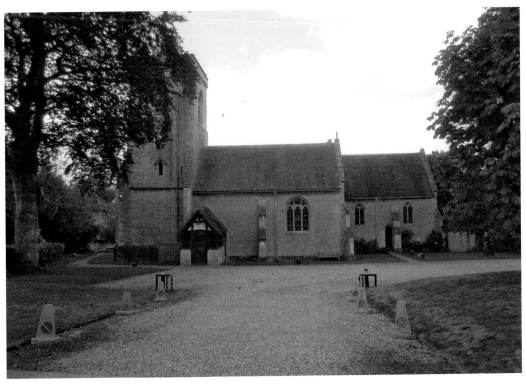

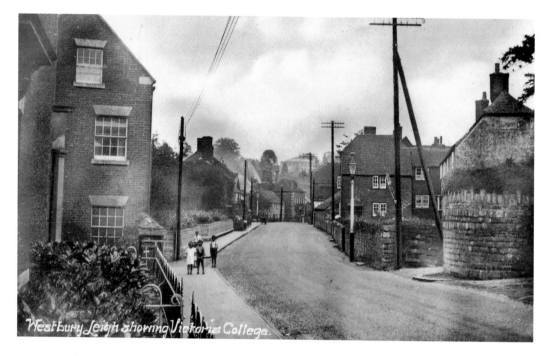

Westbury Leigh, showing Victoria College.

Westbury Leigh, 1930s

On the southern outskirts, Westbury Leigh is now a mainly residential area, although several shops and businesses, including a tanyard, once operated here. The children are standing near the former Sun Inn at the entrance to Church Lane. The last building on the left is now called Leigh House and is mainly from the eighteenth century. Leighton House is visible high in the background; in the modern view it is hidden by trees.

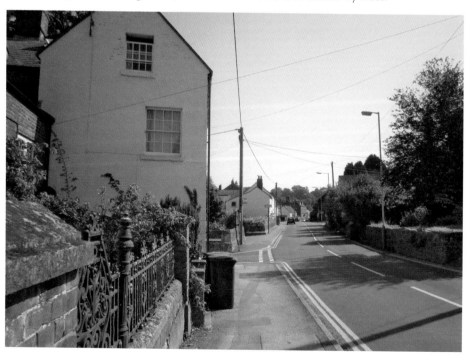

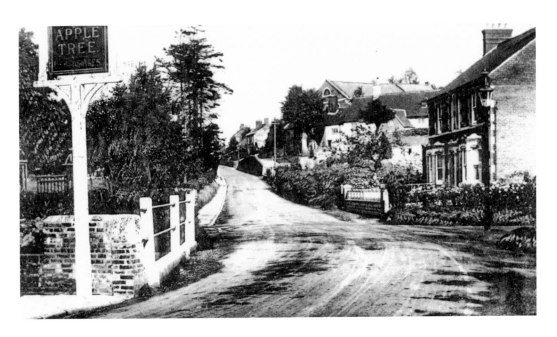

Westbury Leigh, by Biss Brook

At the end of the village a small bridge crosses the Biss Brook. To the right is Mill Lane, as its name suggests, once the site of a mill. The new road layout was created when building started on Leigh Park at the end of the 1990s. Above the cottages on the right the roof of the Baptist church is visible. Built in 1796 and the oldest church in the village, it was closed in 2013.

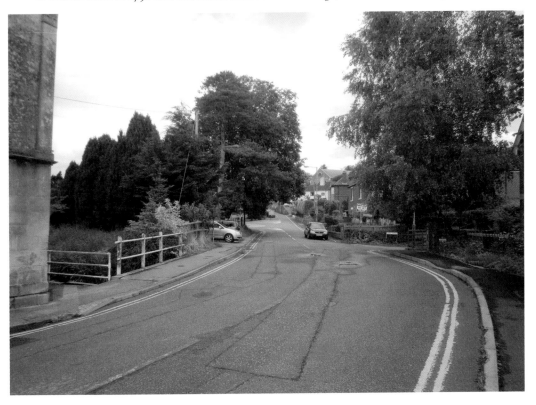

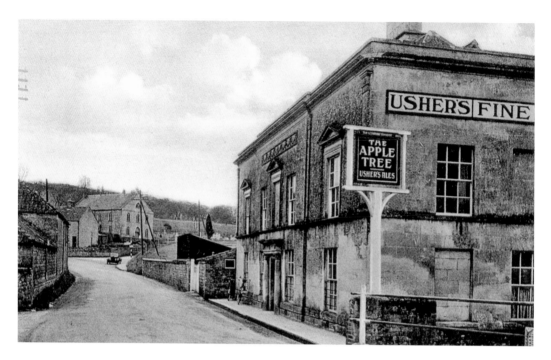

The Apple Tree, Westbury Leigh

Once a fulling or grist mill, parts of this pub are 400 years old with an eighteenth-century frontage. Here they serve local beers from Ushers in Trowbridge. It became a private house after the Second World War. Behind, the Penknap Providence chapel was built in 1810 after a dispute within the Baptist congregation. The trees in the background line the railway embankment. The road is now a dead end. Previously, the turning to the right was to Dilton Marsh, with Frome, via Tower Hill, to the left.

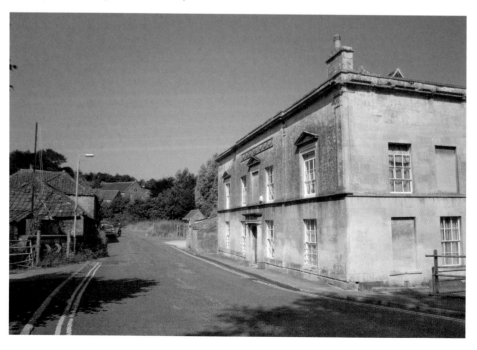

Warminster Through Time

Andrew Pickering & Kathryn Dyer

This fascinating selection of photographs traces some of the many ways in which Warminster has changed and developed over the last century.

978 1 4456 1058 0

96 pages, full colour

Radstock & Midsomer Norton Through Time
Lorna Boyd

This fascinating selection of photographs traces some of the many
ways in which Radstock & Midsomer Norton have changed and
developed over the last century.

978 1 4456 1527 1
96 pages, full colour